HAUNTED
BIRMINGHAM

HAUNTED BIRMINGHAM

ALAN BROWN

HAUNTED
AMERICA

Published by Haunted America

A Division of The History Press

Charleston, SC 29403

www.historypress.net

All images courtesy of the author unless otherwise noted.

First published 2009

Second printing 2012

Manufactured in the United States

ISBN 978.1.59629.614.5

Library of Congress CIP data applied for.

CONTENTS

CONTENTS

INTRODUCTION

The city of Birmingham, Alabama, has gone by a number of names since its founding in 1871 as an industrial enterprise. The presence of all of the raw materials required in the making of steel—iron ore, coal and limestone—made it an ideal location for the steel industry. Named after one of England's principal industrial cities, Birmingham soon became the greatest industrial center in the Southeast, earning it the nicknames "The Pittsburgh of the South" and "The Magic City." The city's growth slowed down somewhat as a result of the cholera epidemic and the Depression of 1873, but it picked up again within a few years. By the turn of the century, Birmingham was known as "The Song of the South" as a result of the growth of its downtown section. A cluster of four office buildings constructed at the intersection of Twentieth Street and First Avenue North in 1912 was called "The Heaviest Corner of the Earth." Growth halted during the Great Depression, although New Deal programs did fund the construction of Vulcan Park, where the symbol of Birmingham's iron and fuel industry—a fifty-five-foot-tall statue of the Roman god of the forge—towers over the city. The demand for steel during World War II gave

Birmingham a much-needed economic boost. Birmingham once again seemed to be a city on the rise. However, an explosion in the Sixteenth Street Baptist Church in 1964, in which four African American girls died, earned the city the derogatory nickname "Bombingham." In the 1970s, the construction of the University of Alabama Medical Center, the growth of the city's banks and the construction of several new skyscrapers inspired the visitors' bureau to label Birmingham "the diverse city."

Today, the city is rapidly acquiring a new handle, thanks in large part to the burgeoning interest in the city's haunted sites. The appearance of the Sloss Furnaces on nationally televised programs like *Scariest Places on Earth* in the 1990s has lured hundreds of paranormal investigators to the city. Other places where paranormal activity has been reported, like the Linn Henley Building and the Tutwiler Hotel, have been covered in the local media for years.

Still, Birmingham's ghost lore is not nearly as rich as that found in much older cities, such as New Orleans, Charleston and Savannah. Consequently, I have been forced to expand the scope of the book to include Columbiana, Jasper, Bessemer and Montevallo, which are, in a sense, bedroom communities of Birmingham. These areas have provided me with a number of wonderfully bizarre tales, which are just as unsettling as the stories found in the city proper. Montevallo is an especially rich source of ghost stories because of its violent Civil War history.

At the time of this writing, the tag line "Alabama's Most Haunted City" has not yet been applied to Birmingham, at least not in the mind of the general public. This development is due in part to the fact that not all of the city's haunted places are willing to exploit their haunted reputations. It is the fond hope of this writer that as more and more people visit the city because of its haunted sites, Birmingham will learn to embrace its connection to the world of the paranormal.

BESSEMER

BESSEMER'S HAUNTED HALL OF HISTORY

The city of Bessemer was founded by Henry F. DeBardeleben in 1887. Like nearby Birmingham, Bessemer had the raw materials required for the production of iron very close by: iron ore, coal and limestone. A network of railways had to be created to transport the raw materials in and out of the area. By 1900, Bessemer had four major railroads. Construction of Bessemer's terminal was completed in March 1916 at a cost of $30,000, mostly by railroad personnel to save the cost of hiring an architect. The building, which still stands at 1905 Alabama Avenue, is 170 feet long and 50 feet wide. The exterior walls are made of pressed brown brick; the interior walls are coated with a wainscoting of terrazzo, which consists of marble chips randomly placed in cement. All of the woodwork is hand-finished heart pine and walnut. Glue was put on the windows and dried to create designs. The terminal had two waiting rooms: a waiting room for "colored" passengers on the left side and a waiting room for white passengers on the right. The depot also had a separate waiting room for white ladies. The segregated

restrooms contained a total of eleven toilets. The terminal was well known for its state-of-the-art vapor heating system, the only one of its kind south of the Ohio River.

In 1973, the terminal was placed on the National Register of Historic Places. In 1985, the Bessemer Hall of History, which had been originally started by the Bessemer Junior Service League in the basement of the old post office, was moved to the old train terminal. Even though the old depot has been put to a different use, its appearance has changed very little since its construction in 1916. Some of the patrons and museum personnel believe that the spirit of one of the exhibits is still there as well.

In the minds of many citizens of Bessemer, the Hall of History will forever be connected to Hazel Farris. At the turn of the century, she was an attractive young woman who was fully aware of the effect her beauty had on men. Dominga N. Toner, director of the Bessemer Hall of History, said that Hazel was "from the other side of the tracks, pretty rough and rowdy." In 1905, twenty-five-year-old Hazel was married and living in Louisville, Kentucky. According to contemporary accounts, on August 6, 1905, Hazel strode into the living room and told her husband that she wanted to buy a new hat. He told her no, and Hazel and her husband began to beat each other with their fists. After a minute or so of fierce fighting, Hazel pushed herself away from her husband, pulled out a pistol and shot him twice. Because both Hazel and her husband were known to drink heavily on occasion, the authorities who investigated the crime later on suspected that alcohol might have fueled their anger. Alerted by the sound of gunfire, Hazel's neighbors alerted the police. Three passing police who heard the gunfire ran inside Hazel's house. Three more gunshots resonated through the neighborhood. When the smoke cleared, all three policemen were dead. A few minutes later, a deputy sheriff entered the

house by the back door and grasped Hazel from behind. In the struggle, his gun discharged, taking off her ring finger from her right hand. Hazel spun around and fired her pistol, making the deputy sheriff the fifth victim of her uncontrollable rage. The mystery surrounding a young woman's ability to shoot and kill five lawmen is heightened by the fact that records show that no police officers were slain in Louisville on August 5, 1905.

Hazel immediately dashed out the door and made her way to Bessemer, Alabama, where she was originally from. A $500 reward was soon posted for her arrest in several states. Dominga N. Toner said that Hazel "ended up in the red-light district, and there was a black lady who lived with her. The black lady was a lot younger than Hazel. She cleaned house and everything." According to another variant of the story, Hazel became the sedate proprietor of a boardinghouse. In yet another version of the tale, Hazel became a schoolteacher who was a closet drinker. A year after fleeing from Louisville, Hazel made a drunken confession of her crime to a man who had professed his love for her. Sensing that he could profit from the woman's secret, her lover betrayed her to the local police in exchange for money. When Hazel learned of his betrayal, she swallowed arsenic while drunk one night and died on December 20, 1906.

Hazel's corpse was taken to the owner of Adams Vermillion Furniture store. Adams also sold caskets and performed funeral services. When it became apparent that no one was going to claim her remains, the store owner placed her body in storage. Within a few months, Hazel's corpse began to mummify. Some people believe that the transformation occurred because of the alcohol and arsenic that Hazel had drunk. Others point to the fact that in 1906, undertakers frequently made their own embalming fluid using arsenic. After a year, Hazel was nothing more than a red-headed skeleton covered with a thin layer of

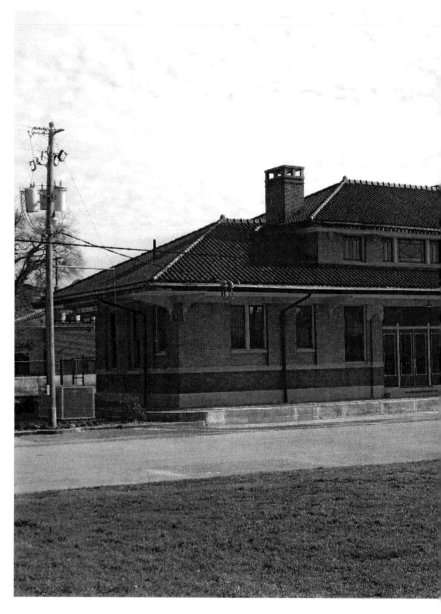

Bessemer Hall of History, erected in 1916. *Courtesy of the Bessemer Hall of History Museum.*

Bessemer

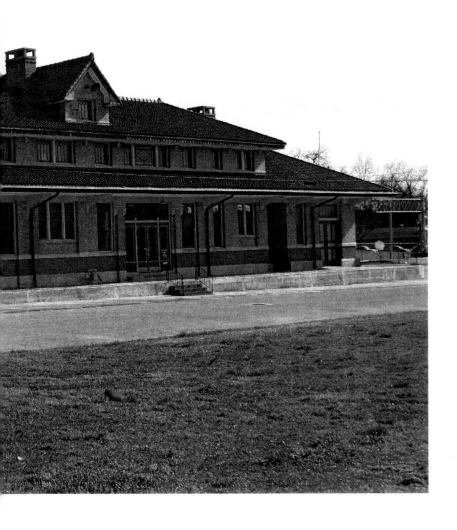

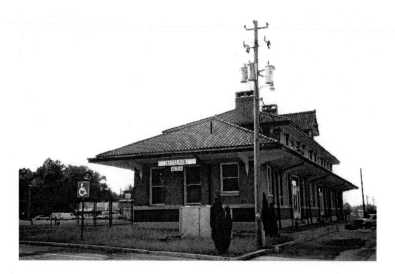

Bessemer Hall of History.

brown, leathery skin. She looked more like a century-old hag than a gorgeous twenty-five-year-old woman. The owner of the store decided to charge people ten cents to view the unusual corpse until her relatives picked up her body.

Some time later, Hazel's corpse was loaned out to various exhibitors, including Adams's brother in Tuscaloosa and Captain Harvey Lee Boswell. Then in 1907, a carny named O.C. Brooks bought her for $25 and exhibited her mummy in fairs and carnivals for the next thirty-two years. His flyers proclaimed, "Moral exhibit for benefit of science." He offered a reward of $500 to anyone who could prove that her mummy was not real. It is said that Brooks was so concerned that Hazel's corpse might be stolen that he slept on top of the pine box where her body was kept. Hazel's profits made O.C. Brooks a wealthy man. In fact, during the Great Depression, the grisly exhibit earned him between $150 and $200 a week. When Brooks died, he left Hazel's mummy to his nephew, Luther, on

the condition that all profits made from exhibiting her corpse be turned over to charity.

When Luther Brooks was thirteen years old, he and his father traveled to Coushatta, Louisiana, to retrieve Hazel Farris from the old barn where her body was stored. When Luther graduated from high school in 1958, he began showing Hazel in a small carnival he had created. The story goes that Luther used the money he made from exhibiting Hazel to build churches in Tennessee. Luther sold the carnival in 1965, and Hazel was placed in a Nashville-area home, where mortuary students from Vanderbilt University dropped by to study her mummy.

Then, in 1974, the Bessemer Hall of History made a deal with Luther Brooks to display Hazel as part of the museum's fundraising drive. When the mummy was first displayed in October 1974, thousands of people paid fifty cents each to view her body in an empty building in downtown Birmingham. Eventually, Hazel was moved to the Hall of History's original location in the basement of the local library. The mummy was displayed around Halloween three more times over the next seven years. When Hazel was displayed for the last time in 1981, the fee had risen to one dollar for adults and fifty cents for children. Hazel's last appearance in Bessemer was at the Hall of Fame's new location in the old railroad terminal in 1994 during Halloween. By that time, Hazel's corpse had lost two gold teeth and was beginning to smell bad. Volunteers had to clean mold from the mummy periodically.

Hazel Farris disappeared totally from public view until 2002, when the National Geographic Channel aired a program entitled *The Mummy Roadshow: An Unwanted Mummy Special.* Dominga Toner remembers when a film crew from National Geographic came to Bessemer:

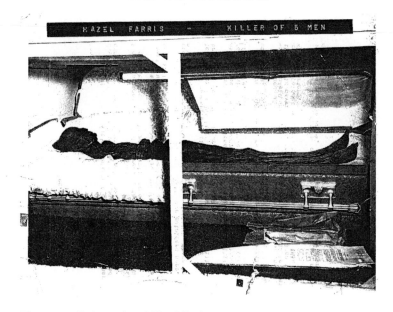

The mummified remains of Hazel Ferris.

I'll tell you the spooky thing about this. I was waiting for them to come into the Hall of History. The funny thing was when they walked through the door, I walked up to the actress who was going to play Hazel and said, "You did a good job! You look just like Hazel!" And the girl looked at me like she was going to kill me. They had just seen pictures of Hazel when she was a mummy. They had never seen her portrait before, and the girl was just the spittin' image of Hazel. She had the hazel eyes and the brown hair. When I showed her the picture, she really got a little undone.

Hazel Farris's autopsy took place at the Pellus-Owen and Wood Funeral Home in Nashville, Tennessee. It was conducted by Ron Beckett, an expert in respiratory therapy, and Jerry Conlogue, an expert in diagnostic imagery. The absence of

arthritis and loss of bone density indicated that she was at least twenty years old when she died. An X-ray of her pelvis revealed a slightly irregular space between the pelvic bones, indicating that she might have had a child. Excited by the possibility that Hazel might have descendants, Beckett and Conlogue scoured the archives in Kentucky, Tennessee and Alabama. Not only did they find no evidence of possible descendants, but they also found no mention of the five murders. The pair then turned their attention to her two missing fingers. One of them was clearly broken off after death; the other stub had a bone spur, suggesting that some growth had taken place over a few months or even a year. Their findings seemed to fit in with the legend.

After having done everything that was possible in the funeral home, Beckett and Conlogue took Hazel to Vanderbilt Medical Center to get more data. A CT scan was used to provide clues as to how she died and became a mummy. The lack of serious decomposition of the internal organs supported the theory that she was embalmed soon after her death. Tissue samples were sent to the University of Western Ontario, where researchers scanned Hazel's hair and skin with an electron microscope. The tests confirmed that high levels of arsenic were present. The researchers concluded that there was far too much arsenic in the leg, arm and hair samples to have come from drinking it. Although the test results did not rule out suicide, they did show conclusively that embalming occurred soon after death.

The final stage of the investigation took place at the Valley View Hospital in Ada, Oklahoma. After removing Hazel's rock-hard chest plate with a strike saw, the researchers found scar tissue in Hazel's lungs, evidence that she might have had pneumonia. Amazingly, her lungs were still soft and spongy after almost one hundred years. The endoscope showed that Hazel's trachea was totally obstructed. Beckett and Conlogue speculated that Hazel

could have vomited after swallowing arsenic and then swallowed the vomit. An examination of the intestines showed that Hazel probably had diarrhea shortly before she died.

Hazel's mummy was never returned to the Bessemer Hall of History. However, Dominga Toner believes that her spirit might still be roaming the old museum: "We have things happen here. Lights go on and off in the men's bathroom. It's really pitch-black in there because there are no windows. I suppose it could just be faulty wiring because this building was constructed in 1916. But we have had lights pop that shouldn't pop." Dominga admits that the problems with the lights could have another cause: "This is a metal frame building. When a train passes, the building jars. The electricity goes up, and my computer screen starts going sideways at an angle." Occasionally, though, visitors to the Hall of History report hearing strange sounds that most likely do not have their source in passing trains: "I've had people come in and say, 'You whistle really pretty,' and I say, 'It can't be me because I don't whistle.' I can't explain the whistling."

Dominga's research into the history of the old train terminal reveals that more than one ghost could be haunting the Hall of History:

This was a passenger station, and bodies were considered passengers up to a certain point in history. They were sent wherever the family requested. A lot of bodies came in here during World War I and World War II, especially during World War II. These were bodies of soldiers who had died. There is a big box downstairs where the bodies were stored. It's metal with a drain plug. They put big blocks of ice in it and put the caskets inside to keep them cool. This was long before the days of air conditioning.

Bessemer

Despite the Hall of History's somewhat grisly history, Dominga Toner has never really felt uncomfortable there. When things happen that she can't explain, she just shrugs them off. "It's just fun, most of the time," she said. The bodies that once occupied a place in the building are long gone, but the mummified corpse that was displayed in the Hall of History still generates nightmares in the minds of people who paid one dollar or fifty cents to view her body years before.

BIRMINGHAM

THE ALABAMA THEATRE

The Alabama Theatre is one of the last of the great movie palaces built in the 1920s to satisfy the public's hunger to see matinee idols like Rudolph Valentino on the silver screen. It was built in 1927 by Paramount Studio's Publix Theater division at 1817 Third Avenue North in downtown Birmingham's Theatre District. The Alabama Theatre was designed by Arthur G. Larson, who worked for the architecture firm of Graven and Mayger. Specially invited guests were invited to a preview of the theatre on Christmas Day 1927. On December 26, 1927, the Alabama Theatre officially opened at noon with a screening of *Spotlight*, starring Esther Ralston and Neil Hamilton. Surrounded by a million dollars' worth of furniture, paintings and statues, the viewers found it difficult to concentrate on the film. They were also distracted by the gold leaf ceiling, the exotic water fountains, the marble floors and the twenty-one-piece Alabama Grand Orchestra, nestled in the orchestra pit. Even though the Alabama was only one of thirty-two theatres that had been built in downtown Birmingham between 1900 and 1929, the

patrons who walked through the golden doors on opening day had no doubt that it was the greatest. In fact, a two-page article in the *Birmingham News-Age-Herald* proclaimed that the Alabama Theatre was the finest movie palace in the entire South.

The showpiece of the Alabama Theatre was a manual, twenty-rank Crawford Special-Publix One Mighty Wurlitzer theatre organ from the Rudolph Wurlitzer Company of North Tonawanda, New York. One of only seven of its type ever built, it was mounted on a screw lift that could raise it to stage level or lower it to orchestra level. Audiences marveled at its twenty sets of pipes, four keyboards and its booming sound. The mighty organ was lovingly dubbed "Big Bertha." Cecil Whitmire, house organist since the 1970s, believes that the organ's name was taken from an old song entitled "Birmingham Bertha."

Even though thousands of people poured through the doors of the theatre when it first opened, keeping the theatre going proved to be a monumental task. The daily operating costs were mind-boggling. On the payroll were musicians, stagehands, a projectionist, ushers, cashiers, doormen, janitors, a managing director and a house director. Bearing the distinction of being the first air-conditioned building in the state was certainly a draw, but it also required the hiring of air-conditioning engineers. The Alabama Theatre also faced competition from the 1,500-seat Ritz Theatre just around the corner and from radio, which was keeping people home. It soon became clear that filling the 2,500 seats every day would be difficult, if not impossible. The only way to survive in this market was to feature as many diverse types of programs and acts as possible.

Over the next few years, the magnificent theatre, which also played host to stage shows and orchestras, acquired the reputation as "The Showplace of the South." Beginning in 1933, meetings of the Mickey Mouse Club were held every Saturday morning

Birmingham

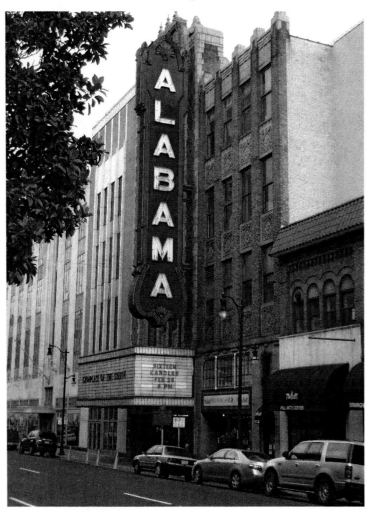

The Alabama Theatre.

at the Alabama Theatre until 1943. The Mickey Mouse Club, which included such honorary members as Amos 'n' Andy, Shirley Temple and President and Mrs. Franklin D. Roosevelt, was praised for getting children involved in different community events. The Alabama Theatre also hosted the Miss Birmingham pageant from 1935 to 1948 and the Miss Alabama pageant from 1949 to 1966. Miss Alabama 1950, Yolande Betbeze, was the only Miss America to have been crowned Miss Alabama on the stage of the Alabama Theatre. James Hatcher, the longtime director of the Miss Alabama pageant, was honored with a star in the Alabama Walk of Fame outside the Alabama Theatre. For the next sixty years, the most popular movies of the day, like *Gone with the Wind*, were shown at the Alabama Theatre.

Birmingham's movie theatres underwent a period of decline in the 1960s and 1970s, partially because of the increasing popularity of television. Beginning in the 1950s, fewer people were frequenting the restaurants and department stores in downtown Birmingham. After the last big department store closed in 1977, the Alabama Theatre was forced to show movies all day for one dollar a day just to survive. By 1980, most of the city's movie theatres had been closed. In 1981, the Alabama Theatre began showing a series of classic films entitled "Recapture the Spirit of the Alabama" in an effort to reclaim its audience, but to no avail. That same year, the Alabama Theatre was sold to Cobb Theaters of Birmingham. Over the next few years, Cobb Theaters tried several times to reopen the Alabama, but with no success.

The Alabama Theatre was sold once again, this time to a developing group named Costa and Head, which attempted to capitalize on the Alabama Theatre's movie palace aura by showing classic films. For a while, the Alabama Theatre attracted movie buffs who were eager to view these old films

on the largest movie screen in the entire state, but ticket sales were not large enough to keep the theatre afloat. The Alabama Theatre closed in the spring of 1981. In 1986, the owners of the theatre declared bankruptcy.

Help came a year later from the Alabama Chapter of the American Theater Organ Society, which initiated fundraising efforts to purchase the theatre when Costa and Head refused to allow the Wurlitzer organ to be removed. In 1987, a group called Birmingham Landmarks, Inc., was formed to buy and operate the old theatre. The Downtown Action Committee (DAC) and the *Birmingham News* backed a campaign to raise the $196,000 required to bring the mortgage current and to assume the present mortgage of the Alabama Theatre. On May 3, 1987, federal bankruptcy judge Stephen Coleman allowed Birmingham Landmarks, Inc., to buy the theatre. To herald the Alabama Theatre's rebirth, the new owners renamed it the Alabama Theatre for the Performing Arts.

For the next few years, the Alabama Theatre for the Performing Arts set about forging a new identity for itself. It started out showing classic movies and staging organ music with sing-a-longs. When the appeal of the old movies began to wane and the crowds dwindled, management began booking live shows and rock concerts. Concert performances by groups like the Black Crowes and Megadeth and live performances by entertainers like k.d. lang and Wynton Marsalis soon became the mainstay of the Alabama Theatre for the Performing Arts. Classic films are still being shown there as well.

In 1998, the Alabama Theatre for the Performing Arts underwent extensive renovations at a cost of $1.5 million. Seats on the main floor were replaced with larger ones. New drapes were installed in the organ chambers and on the stage; the old carpeting in the ladies' lounge was replaced as well. Workmen

removed smoke stains around the air vents, which had been there since 1934 when the original Loveman's department store burned down. Plaster finishes, stenciling and gilding were restored by New York's Evergreene Studio. In 2008, the Hills Art Center was opened in the building next door as a means of enabling the Alabama Theatre to expand its special events facilities. One element of the elegant theatre's past that has resisted the ravages of time is the legend of the ghost of the Alabama Theatre, which has been passed down from theatre manager to theatre manager since 1927.

Cecil Whitmire, who was the organist from 1976 until his retirement in 2007, is one of the best sources for stories about the ghost that haunts the old theatre. To help raise money for the organ's upkeep after the Alabama Theatre closed in 1981, Cecil performed two concerts a year. One Saturday night in 1986, Cecil and four other people gathered inside the theatre to prepare for a benefit concert that was to be held Sunday afternoon. Cecil was accompanying the soloist as she sang "Memory" from the musical *Cats*. He and the soloist were trying to learn each other's rhythm through eye contact. Workmen in the balcony and behind the curtain were trying to get the lighting just right. Everyone else was getting the concession stand ready. The soloist turned her head so that she could get a better look at the organist's face just as they were coming to a very dramatic part of the song. From her vantage point, she could also see the curtain and the proscenium edge of the stage. Suddenly, out of the corner of her eye, she caught a glimpse of the shadowy profile of someone emerge from the curtains, walk across the stage and disappear on the other side. Cecil also saw a figure walk behind the screen, but his initial thought was that it was one of the people who were in the theatre. He did not realize that at the time, everyone was in the auditorium. "The soloist saw it

26

better than I did because she was turned a different way," Cecil said. When practice was over, Cecil and the soloist discussed the unscheduled "personal appearance" that took place on the stage that night. They concluded that the apparition could have been the spirit of Stanleigh Malotte, who was the primary house organist from 1936 to 1955.

Other people have seen the ghost as well. "People have heard doors slam and footsteps in empty hallways. They have also seen curtains blow in unusual places," Cecil said. In 2000, a wedding was being held at the Alabama Theatre on Halloween. Just before the ceremony began, the maid of honor saw a lady in a red velvet dress walk toward the end of the hallway. Suddenly, she was pulled against the wall by what appeared to be the ghost of a male.

One of the most frightening incidents in the Alabama Theatre occurred when a new employee was in the balcony checking seats for line of sight for a special program that had an interpretation screen above the stage. "She wanted to make sure everyone could see," Cecil said. "So she was sitting in various seats to check this out. These seats automatically flip up. As she sat down in her seat, a seat two seats down the row went down with her. She immediately got up and left."

One of the landmark events in the life of the Alabama Theatre was the showing of the 1925 silent movie *The Phantom of the Opera* in 1979. The original score for the film was written by organist Tom Helms, who accompanied the film on "Big Bertha." The film is shown every year on the Saturday before Halloween with Tom Helms on the organ. However, according to longtime employees, performers and theatre-goers, the Alabama Theatre's resident phantom entertains eyewitnesses during the entire year.

BASS CEMETERY

Old cemeteries in remote areas have stimulated the imaginations of young people in the South for decades. Visiting Pilot's Knobb Cemetery in Marion, Kentucky, in the dead of night has become a rite of passage for teenagers eager to catch a glimpse of the ghost of the witch's daughter as she paces back and forth inside the picket fence enclosing her grave. Teenage boys living in Knoxville, Tennessee, take their girlfriends to Old Gray Cemetery in the hope that a ghost known as "Black Aggie" will frighten their girlfriends into their waiting arms. In Jefferson County, Alabama, teenagers prowl around Bass Cemetery in search of supernatural thrills.

Bass Cemetery is located on County Road 147 approximately one and a half miles east of First Avenue North in Birmingham. The cemetery is bordered by dense woods on its east and west perimeters and by the Norfolk Southern Railroad to the north. The oldest tombstone bears the date March 22, 1860. Approximately 321 people are buried there, including 5 veterans of the Civil War, 1 veteran of the Spanish-American War, 3 veterans of World War I, 8 veterans of World War II and 1 veteran of the Korean War. Engraved on the tombstones are fairly conventional epitaphs from the nineteenth century, such as "Gone but not forgotten," "He was beloved by God and man," "A tender mother and faithful friend" and "Our loved ones are together in Glory." In many ways, Bass Cemetery is a fairly typical southern cemetery ravaged by vandalism and the passing of time. According to the young people who venture into the old cemetery late at night to prove their courage, however, Bass Cemetery is anything but "normal."

Stories of ghostly encounters in Bass Cemetery have been circulating around Birmingham for generations. Some people

claim to have caught "snapshot" glimpses of shadowy figures that vanish seconds after they first appear. Others walking through the cemetery at midnight report feeling as if someone is following them. When they turn around, however, no one is there. Screams coming from the general area of the cemetery pierce the night air. It is said that when one turns off the ignition and cuts off the headlights of a car, the windows fog up. After the driver opens the door and walks around the car, he or she notices handprints on the side panels and the roof. People have also found the mutilated corpses of small animals in Bass Cemetery, leading some to speculate that Satanists might be holding black masses there. On November 20, 2006, a ghost-hunting group posted a video on YouTube of a Coke can placed on a tombstone near a mausoleum. While one of the ghost hunters asks the spirits to move the can, a pair of disembodied legs walks in front of the camera.

Even though Bass Cemetery is set off from the hustle and bustle of the city, vandals have damaged or destroyed many of the tombstones. In fact, approximately 25 percent of the tombstones have been so badly damaged that the names are impossible to read. Some tombstones have been dislodged from their foundations, while others have been removed completely from the graveyard. One of the crypts appears to have been looted. Even the coffin is gone. One wonders if the disrespectful treatment of the dear departed—a serious crime in the folk traditions of most cultures—might have stirred some of these resentful spirits.

HAINTS IN THE HOMEWOOD PUBLIC LIBRARY

Homewood, a suburb of Birmingham, has one of the highest population densities in the state, owing, in part, to the fact that it seems to be insulated from most of the problems that inflict large urban centers, like Birmingham. Homewood is a city that loves books. Daniel Wallace, author of *Big Fish*, and children's author and poet Charles Ghigna call Birmingham home. The Homewood Public Library's circulation may not equal that of the Birmingham Public Library's, but it is just as busy. And, like the Linn Henley Building, the Homewood Public Library is said to be haunted.

The spiritual activity within the Homewood Public Library might be due, at least in part, to the building's unique history. Longtime librarian Deborah Fout says that the Homewood Public Library stands on the site of a farmhouse: "The owner came out and talked to us about [the old house]. He said his mother and his aunts all stayed in that house. [At the time when they lived there], the house stood in the middle of a pasture." The Church of Christ was built on the site of the farmhouse in the late 1960s. The church and the surrounding property were purchased in 1984. Following extensive remodeling, the Homewood Public Library opened its doors in 1986. The building underwent subsequent renovations in 1996 and 1998.

Patrons and librarians have always heard voices in the library. Deborah Fout says that as a rule, the voices seem to be coming from downstairs. "You can't tell what the voices are saying," Deborah said. "It sounds like a group of women talking together." Some people believe that these are the spirits of women who attended the Church of Christ and do not realize that the building is now serving another purpose.

Birmingham

The paranormal activity in the Homewood Public Library seems to have escalated when the building was remodeled in the 1990s. In 1996, when a work crew came in to do their research work, the foreman walked up to Deborah and asked her if the library was built on top of a graveyard. "I asked him why, and he said they couldn't get any readings on their instruments because they were going crazy out there," Deborah said.

The workers who installed the sprinkler system in the adult services department a few weeks later had some really startling experiences. Deborah remembered,

> *They were putting in the sprinkler system between 8:00 p.m. and 4:00 a.m. They'd come in after we closed and finish before we opened in the morning. One night, the lights began going off and on by themselves. A few minutes later, some lightweight metal studs began moving across the floor by themselves. Then the electrical cords starting dancing in the air, like snakes. They got so scared that they took off in the middle of the night and left all of their tools in the library. Later that night, they called the police and had them come into the library and get their tools.*

When the foreman of the work crew found out what had happened, he had them all drug tested. "One of the workmen refused to come back inside the library," Deborah said.

Deborah also had an unnerving experience in the library one Friday night in 1996 when the library was being remodeled. Her office had been moved to a very small space downstairs while the upstairs rooms were being renovated. One night, she stayed after closing hours to catch up on some work. There was no one else in the building at the time.

31

I had to go to the restroom, and there was nobody else in the building, so I just left my door standing open and went to the restroom. Then when I came back, my door was closed. It scared me to death because I thought, "My keys are in there. I locked my keys in the office, and here I am up here!" I checked my door, and it was closed, but it wasn't locked. I knew I had left it open. So the next time, when I went to the restroom, I took my keys with me, and I locked the door, and I checked myself on it, and when I came back, the door was open. Then I got my stuff and left.

Since this incident, Deborah has not been very frightened inside the library.

Other people have also had strange experiences in the Homewood Public Library. Roosevelt Hatcher, the information systems manager, stayed late in the library one night in 1996 while upgrading the computers. All at once, he was distracted by the sound of women talking. They were laughing and joking and, apparently, enjoying one another's company. At first, he thought that a radio had been left on in one of the administrative offices. He began checking out the offices, but no radios had been left on and no one else was present. Then, when he walked through the doorway of one of the offices, the talking ceased altogether.

Former director Edith Harwell became very frightened while she was working late one night. She was hard at work when she heard the sound of car doors slamming in the parking lot. Because the library was closed, she knew that whoever was sitting in the parking lot was not there on library business. Edith left her office and walked out the front door of the library to the parking office. Nobody was there. "I was so spooked that I turned off the lights and went home right then and there!" Edith said. "I was in such a hurry to leave that I forgot to turn off the alarm. We

Homewood Public Library.

had to send somebody to the library to turn off the alarm later that night."

Deborah Fout does not believe that the spirits are dangerous, but she does not enjoy being in the library by herself: "I used to stay late at night and get caught up on my work, but I don't do it anymore. I can't take it. I used to come in on Sundays. We open at one o'clock, and some Sundays when I didn't go to church, I'd come in during the mornings and do some work. It just got to where I got too spooked, so I don't come in really early anymore." Because the hauntings usually occur after the library has closed, most of the ghostly occurrences have not been corroborated by other eyewitnesses. "We never have any experiences when the library's open," Deborah said. "It usually happens at night or when there's nobody else in the building. But you get the sense that there's somebody in here when there's not." Reports of paranormal activity in the Homewood Public Library declined in the 2000s. Chances are that the library's ghosts will remain dormant until the building undergoes additional renovations.

THE LINN HENLEY BUILDING

The Birmingham Public Library was originally established in a room adjoining the office of the superintendent of the public school system, John Herbert Phillips, in 1886. After the public library board was set up in 1913, the library was moved to city hall. Following the destruction of city hall in a devastating fire in 1925, the city decided to house the library in a brand-new building. Two years later, the Birmingham Public Library opened in a magnificent neoclassical building of Indiana limestone. For the next fifty-seven years, the building served as the central facility of the Birmingham Public Library. In 1984, the library finally outgrew the 1927 building and was moved to a new library across the street. Containing 133,000 square feet of floor space, the present structure now houses most of the central library's circulating and general reference collection, as well as the technical services for the library system. Following an extensive renovation project in 1985, the old library building reopened in 1985 and was renamed the Linn Henley Building in honor of two of Birmingham's founding families. The Linn Henley Building was renovated and now houses the Archives and Manuscripts Department, the Southern History Department, the Government Documents and Microforms Department, the Computer Center and various administrative offices. According to the testimony of employees and patrons, the Linn Henley Building is also the eternal home of a former librarian.

Fant Hill Thornley was born in Pickens, South Carolina, on June 1, 1901. He attended Presbyterian College in Clinton, South Carolina, and majored in library science at the University of North Carolina at Chapel Hill. After serving in the U.S. Marine Corps between 1943 and 1945, he worked for several years as a librarian at the Richland County Public Library in Columbia,

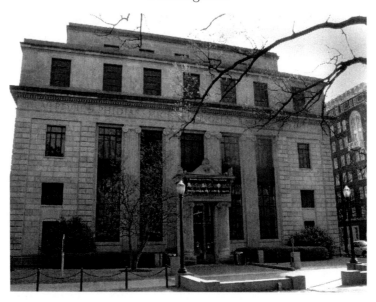

The Linn Henley Building.

South Carolina, before being hired as the assistant director of the Birmingham Public Library in 1949. When the director, Emily M. Danton, retired in 1953, Thornley took over the duties of library director. For the next seventeen years, Thornley piloted a number of major improvements in Birmingham's library system. He supervised the construction of four new branch libraries and arranged for seven older branches to move to new facilities. In 1963, Thornley also quietly integrated the Birmingham libraries, a very bold move considering that segregation was the rule rather than the exception at the time. Thornley died of a heart attack in his Claridge apartment off Highland Avenue on April 12, 1970. He left behind a library system that had increased its circulation to 3.5 million books, the greatest circulation in the entire South.

Interior of the Linn Henley Building.

If the legends can be believed, Fant Thornley's dedication to his job has lasted far beyond the grave. For years, people suspected that the library was haunted because of odd things that happened periodically on the third floor, such as phantom knocking sounds, books falling off shelves or lights blinking inexplicably. In October 1977, shortly before Halloween, library director Marvin Whiting had a particularly unnerving encounter with the ghost of the Linn Henley Building. Whiting was cataloguing newspapers in his office on the third floor at 11:30 p.m. He was sitting at his desk typing and paused to correct an error he had made when he heard the elevator climb up to the third floor. Whiting expected to see the security guard, the only other person inside the library that night, when the door opened. To his surprise, no one was inside the elevator. Thirty seconds later, one of the swinging doors to the archives pushed open. "It stayed open less than thirty seconds and closed," Whiting said. "The full-sized double doors leading into the archives, which for the past four years housed the library's audiovisual department, are heavy doors," Whiting said. At that moment, Whiting detected the distinctive aroma of Chesterfield cigarettes, Fant Thornley's favorite brand. Whiting immediately contacted the visibly shaken security guard, who said that no one else was in the library at the time. He told Whiting that although the elevator had malfunctioned occasionally, it had never gone to a floor, stopped, opened its doors and then descended to the first floor without a passenger. The paranormal explanation for the elevator's strange behavior became even more plausible when Whiting found out that the janitor was not a smoker. As Whiting returned to his work, he had no doubt that he was in the presence of the ghost of Fant Thornley.

The next day, Whiting told the library staff that he had seen the ghost of Fant Thornley. "Though I had never met

him, I was told Fant Thornley was a lover of rare books and he was responsible for acquiring most of the library's rare map collection," Whiting said. "It made sense to me that if his ghost was around, he would most likely stay in the library because I understand that he was most comfortable here." The fact that Thornley smoked in the library also convinced Whiting that the former librarian had returned to his place of employment that October night.

In 1989, an electrician working in the stacks on the third floor had a terrifying encounter with the library's ghost. The electrician was working on the wiring when he felt the presence of someone standing behind him. He turned around and saw a man whom the electrician said "did not look real." In one version of the story, the spectral figure actually spoke to the librarian before disappearing. In another version, the electrician immediately ran down the stairs and told the librarians, in a trembling voice, what he had seen. Several staff members showed the man a group of photographs of former employees of the library. After looking at the photographs for a few minutes, the electrician put his finger on Thornley's picture and said, "That's him. That's the man I saw." He refused to return to the third floor unless someone walked up there with him.

Fant Thornley's ghost made another appearance in the late 1990s. Archivist Jim Baggett said that one afternoon, a young woman who used to work in the library's administrative offices was in the auditorium setting up refreshments. "When you go into the auditorium, the stage is in this end of the room," Baggett said. In the back are tables where they set up refreshments. There's a doorway that leads to the kitchen. The young lady said that she was alone in the library when she was putting out drinks and things. She looked over, and there was a man in a 1950s-era suit standing in the kitchen doorway. She said she looked at him,

and he vanished. The young lady ran out of the auditorium and told her co-workers what she had seen. However, unlike the electrician, she was unable to pick out Thornley's picture from a stack of photographs of other former librarians.

Archivist Jim Baggett says that the electrician is not the only person who has felt uncomfortable in the stacks on the third floor. "We have had staff members who haven't seen anything, but because of the doors opening and closing they won't go into the stacks. We had a young lady a few years ago who wouldn't go back into the stacks unless someone went in there first and turned on all the lights."

Intrigued by the information provided by Jim Baggett, I stopped off at the Linn Henley Building one fall afternoon in 2003 to take photographs. While sitting in the parking lot across the street, I loaded my camera with brand-new film and new batteries and walked in the front door of the Linn Henley Building. I immediately began taking photographs in the reading room on the first floor. I then climbed up the stairs and started taking pictures of the first floor from the second-floor balcony. Suddenly, my camera stopped working. The battery light indicated that my batteries were dead. Unfortunately, I had no other batteries with me and was forced to end my "ghost hunt." While I was walking down the stairs, I remembered the experiences of paranormal investigators who claimed that their cameras' batteries had been drained by spirits who were trying to manifest themselves.

Haunted libraries are a common element in American ghost lore. The Williard Library in Evansville, Indiana, is said to be haunted by the spirit of the Lady in Gray. The ghost of a violin-playing janitor walks the halls of the Houston Public Library. An eyewitness has identified the ghost that haunts the Julia Tutwiler Resource Center on the campus of the University of

West Alabama as the spirit of Lucille Foust, the principal of the laboratory school in the 1930s. If Fant Thornley's ghost really does haunt the Linn Henley Building in Birmingham, he has probably done so out of a sense of dedication. Alabama folklore writer Kathryn Tucker Windham says, "Fant evidently comes back from time to keep an eye on what is going on at the library." It is also possible that the alterations that have been made to the building since Thornley's death in 1970 might have awakened his spirit.

THE TUTWILER HOTEL

The Tutwiler Hotel had its inception in a statement made by the president of the Tennessee Coal, Iron & Railroad Company. In 1907, George Gordon Crawford told Robert Jemison Jr. that when members of the finance committee came to visit him in Birmingham to consider appropriations for the modernization of existing plants and the building of new ones, they spent most of their time complaining of inadequate hotel facilities. Realizing that Crawford's concerns were valid, Jemison began looking for the perfect site for the kind of luxury hotel that would attract businessmen like George Gordon Crawford to Birmingham. He settled on a 140- by 150-foot lot on the east corner of Fifth Avenue and Twentieth Street owned by Harvey Woodward. Jemison challenged Crawford and other businessmen to join him in what promised to be a very profitable business venture. One of the businessmen Jemison approached was Major Edward Magruder Tutwiler, who agreed to sell his interest in the Tutwiler Coal & Coke Company at a price around $1,850,000 to underwrite the first mortgage bonds for the new

hotel. Tutwiler's only condition was that the new hotel be named "The Tutwiler." Because Tutwiler was the largest shareholder in the project, Jemison happily granted Tutwiler's request.

The plans for the hotel were a composite of the varied floor levels of the Blackstone Hotel of Chicago, the vaulted ceilings of the Vanderbilt Hotel of New York and the terra cotta and fisk tapestry brick exterior of the MacAlpin Hotel of New York. Flower boxes, of the type featured in the Vanderbilt Hotel, would be used to divide the lounge and café space on the mezzanine floor. The owner of the Statler Hotel in New York recommended the installation of pipe chacers from basement to roof. As a result of the planners' desire to construct Birmingham's first truly luxury hotel, final building costs soared to $1,600,000. The investors' dream became a reality when the Tutwiler Hotel opened its doors on June 15, 1914.

For the next sixty years, the Tutwiler reigned as the grande dame of Birmingham's hostelries. For years, it was the scene of a multitude of business, social and political functions. Celebrities, politicians and dignitaries from all over the United States traveled hundreds of miles to walk through its doors. In 1927, Charles Lindbergh held a press conference in the Louis XIV Suite. President Warren G. Harding, who had traveled to Birmingham to help celebrate the city's semicentennial, slept at the Tutwiler. Tallulah Bankhead threw a postwedding party in the Centennial Room.

By the 1970s, the Tutwiler Hotel's glory days were long in the past. Finally, in 1974, plans were made to demolish the old hotel to make room for a new bank. On January 27, 1974, the Tutwiler made history as one of the first buildings to be imploded. However, the razing of the hotel proved to be much more difficult than Jack Loizeaux, chief of Controlled Demolition, Inc., had imagined. Following the initial explosion, the south wing was

still standing, primarily because the Tutwiler was supported by a skeleton of structural steel instead of reinforced concrete. Total destruction of the remaining structure was not completed until several weeks later.

The Tutwiler Hotel returned over a decade later when the hotel management firm of Lincoln Hotel Corporation set about renovating the eight-story Ridgely Hotel at Twenty-first Street North and Park Place. It had been built by Major Tutwiler the same year that ground was broken for the original Tutwiler Hotel. For years, the Ridgely operated as an "apartment hotel," where residents lived on both a transient and a full-time basis. The architectural firm of Kidd/Plosser/Sprague was hired to convert the historic but worn Ridgely Apartments into a shining new Tutwiler Hotel. Birmingham received an $897,000 urban development action grant for the $15 million Ridgely project. The architects strove to maintain the character of the original 1914 building, including the preservation of the original fireplaces. A black-tie gala was held on December 13, 1986, to celebrate the grand opening of the newly renamed Tutwiler Hotel. Proceeds from the $75 ticket price benefited the Birmingham Historical Society.

Today, the eight-story Tutwiler Hotel retains much of the splendor of its predecessor. The 149-room hotel has thirteen different room layouts on each floor. The hotel includes 53 suites, 96 standard guestrooms, 4 banquet and meeting rooms and a restaurant and bar. The lobby area, which has 2 separate anterooms with fireplaces, is resplendent in a décor of tapestries and Italian marble. A first-floor meeting room is trimmed in dark-stained oak beams and cloth-covered walls. The original terra-cotta cornices, which had been removed years before when they deteriorated beyond repair, were replaced with fiberglass cornices at a cost of $400,000. A citation by the National

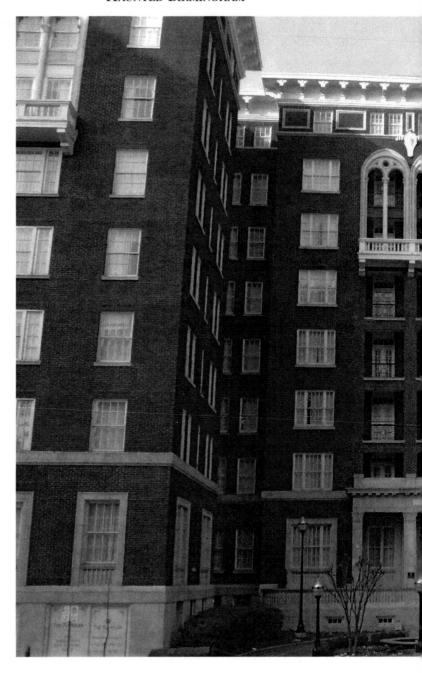

The Tutwiler Hotel.

Birmingham

Trust for Historic Preservation is proof that the new owners have succeeded in their efforts to restore the Tutwiler's Old World charm. Eyewitness testimony from guests and employees suggests that the extensive renovations might have awakened the dormant spirit of Major Tutwiler as well.

In paranormal circles, the Tutwiler Hotel has earned a reputation as a place where guests are likely to receive attention from beings other than maids and bellboys. A bell captain who has worked at the Tutwiler Hotel since 2004 has never seen a ghost in the hotel, but he has had experiences with something that he calls a "knocker." Guests staying on the sixth floor have called him up in the middle of the night to complain about being awakened by someone knocking on the door. By the time the guests walk groggily across the room and open the door, no one is there. In November 2004, a female guest staying in room 604 informed the bell captain over the phone that someone was knocking on her door and she was really frightened. When the bell captain walked into room 604, she was sitting on the bed, shaking uncontrollably. After she calmed down, she told the bell captain that she was awakened by frantic knocking on her door. Sensing that there was an emergency, she jumped out of bed and opened the door. When she opened the door and stepped outside, she was shocked to find that the hallway was completely empty. All at once, she felt as if she was in the presence of something unearthly. She retreated back inside her room and slammed the door. The bell captain believes that the Tutwiler Hotel was haunted long before he began working there: "I've had some guests who have been staying at the hotel for the past ten or fifteen years tell me about the ghost knocking on their door." He has concluded that the ghost must be male because most of the recipients of his midnight visits are female.

Birmingham

The Tutwiler Hotel's best-known ghost story took place late one night in 1995. The bartender was in the restaurant, turning off the lights and stoves, just as he had been doing for years. He had just clocked out and was leaving the restaurant when he felt the urge to look back. To his surprise, the lights were back on. When he walked back inside, he was shocked to find that the stoves were turned on as well. He turned off all the lights and appliances and walked out the doorway. When he turned around, the lights and stoves were turned on once again. The bartender tried two more times to turn everything off before finally giving up and going home. As the bartender had expected, the general manager did not accept his explanation that "something" inside the restaurant kept turning everything back on. For five nights, the bartender tried everything in his power to keep the lights and appliances turned off, but to no avail. On the morning of the sixth day, the bartender walked into the general manager's office, fully expecting to receive a "tongue lashing," just as he had the previous five mornings. Instead of "chewing him out," the general manager told the bartender to follow him to the restaurant. "I've got something to show you," he said. Expecting the worst, the bartender followed the general manager. He gazed in amazement at one of the tables, on which someone—or something—had set a full-course meal and placed a bottle of vintage wine. The curtains were drawn as well, as if the waiter were trying to create an intimate atmosphere. All of the employees of the hotel were interviewed, but no logical explanation for the "midnight dinner" was ever found. Working on the theory that the perpetrator was the ghost of Mr. Tutwiler, the bartender began saying, "Goodnight, Mr. Tutwiler. Please turn off the lights, and don't make a mess!" before closing up the restaurant. For over a decade, no nocturnal activity inside the restaurant has occurred.

Even believers in the paranormal have difficulty understanding why Mr. Tutwiler's ghost haunts the new Tutwiler Hotel, but his spirit has never been reported inside the original hotel. The answer is more obvious than it might appear to be. Mr. Tutwiler never really lived in the first Tutwiler Hotel, but he did live in the Ridgely Apartments. Could it be that Tutwiler's spirit, like the Tutwiler Hotel, has been resurrected?

THE REDMONT HOTEL

Named for Birmingham's red clay mountains, the Redmont Hotel first opened its doors on May 1, 1925, during the height of the Jazz Age. It was one of several hotels constructed in the 1920s to satisfy the growing need for luxury accommodations. With its polished metal floors, private baths and elegant ballroom, the 225-room Redmont lived up to its reputation as one of the city's finest hotels. It was the first downtown hotel with a bath in each room. In the halcyon days prior to the Great Depression, Birmingham's elite lived the high life at the Redmont, celebrating New Year's Eve, weddings, proms and anniversaries in its lavish ballroom. Visiting celebrities rubbed elbows with local politicians, honeymooning couples and debutantes. The Rainbow Room, which was added in 1937, attracted a number of businessmen, politicians, bankers and ministers, some of whom formed a loosely knit group known as the "Knothole Gang." After Clifford Stiles bought the Redmont Hotel in 1946, the New York–style penthouse that he created for himself on the fourteenth floor became the focal point for Birmingham's social scene. Soil was loaded onto the service elevator and transported to the rooftop, where landscapers leveled it out and planted flowers. Stiles

Birmingham

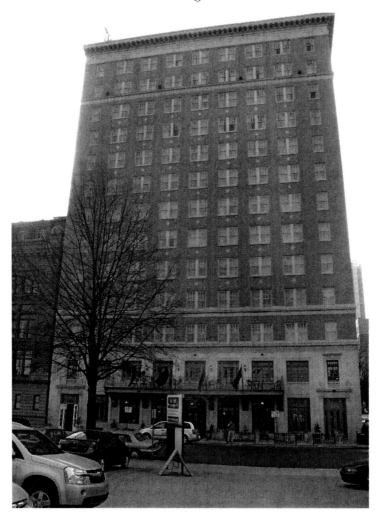

The Redmont Hotel.

also constructed a brick barbecue pit and a concrete patio. For years, the extravagant parties Stiles threw in his penthouse were attended by luminaries such as Governor "Big Jim" Folsom.

After World War II, when people began flocking to the suburbs, downtown Birmingham became a repository of relics like the Redmont Hotel. Because Stiles, who was still living in the fourteenth-floor penthouse as late as 1971, did not spend much money maintaining the Redmont, the old hotel started to become run-down. The Redmont changed hands several times in the 1950s, but Stiles continued his involvement with the hotel until his death in Las Vegas in 1976. In 1979, the Redmont Hotel was owned by Mrs. Betty Koehler. She had started as a maid in Stiles's Holiday Inn in Panama City, Florida, and had worked her way up through the ranks to the position of manager of the Redmont. In May 1980, a group of New York investors bought the hotel with the intention of turning it into a monthly rental residential club for the elderly. The proposed name for the hotel's latest incarnation was "the Mayfair House."

However, by the end of the decade, the dilapidated old hotel was known not as a showplace for the high and mighty, but as a house of ill repute. When the Redmont finally closed down in 1983, it was a flophouse, a place that transient construction workers, retired schoolteachers, lawyers and businessmen, street beggars and prostitutes called home. The penthouse area was a pathetic reminder of better days. Ornate lawn furniture, rusty with age, remained where it had been placed years before. An elegantly styled gate was set to one side. The four-foot-wide ledge where Stiles's three daughters used to walk their dog was nothing more than a jumble of concrete blocks. Years of rain had toppled the iron fence that once lined the ledge. The roots of trees pierced the planters and grew right down into the concrete. Here and there were stacks of empty planters. Windows were

shattered, and pieces of broken concrete littered the barbecue pit area. Tall weeds had replaced the flowers and bushes that once decorated the landscape. Old mattresses and broken furniture from the hotel were piled in the living room where Mrs. Helen Stiles's grand piano once stood. The sidewalk in front of the hotel was covered with vagrants and pigeon droppings. Many of the large windows were covered with a thick layer of bluish-green paint. One of the wood panels, which had served as a sign for the Redmont Lounge, pictured a naked blonde sitting on a half-empty glass of pink champagne. The lobby, which had served as the grand entrance to the hotel, was a shadow of its former self. The air was thick with mildew, ornate beams sagged precariously and large pieces of plaster from the ceiling covered the marble floor. On one floor of the Redmont, the walls were painted hot pink. In one hallway was a small check-in counter for customers whose stay at the Redmont would be short. Between 1983 and 1984, vandals broke into the Redmont and smashed toilets on the upper floors. Water, which had been leaking into the hotel for several weeks, caused considerable damage to the ceilings and floors. The neon sign atop the thirteen-story brick tower said "HOTEL REDMO T" on one side.

Even toward the end, though, vestiges of the old hotel's glory days remained. In 1982, an elevator man in a fresh white shirt with red epaulets was still on the job. Alice Goodwin, who had been a singer at the Redmont for twenty years, was still a fixture at the hotel. Loveless Reese, the bellman, continued to help guests carry their luggage to their rooms, just as he had been doing for thirty years.

The Redmont Hotel was saved in the early 1980s, thanks in large part to Birmingham's efforts to revitalize its downtown area. The Redmont was scheduled to be converted into an office-condominium complex until it was purchased in 1984 by

the Redmont Hotel Ltd., a group of thirty-five investors that was formed by Birmingham financial planner Robert Straka. Members of the group included local businessmen, professional hockey players and several National Basketball Association stars, such as Ralph Sampson and Kareem Abdul-Jabbar. Redmont Hotel Ltd. sold the land on which the Redmont stands to the Alabama Symphony Orchestra as a tax write-off. The investment group agreed to lease the land from the symphony for $50,000 a year. The group spent more than $12 million in extensive renovations. The remodeling project was a joint undertaking of Cox Realty and Development Company and Marion Bradford Associates, an architectural firm. The renovation of the hotel required the elimination of eighty rooms and the expansion of the remaining rooms. The interior walls were stripped and repainted. All of the furnishings were removed; the foundation, pillars and elevator shafts were all that remained of the original building. Workers also installed new air conditioning, plumbing, electrical systems and elevators. In addition, the marble floors were polished, and the lobby was refurbished. Loveless Reese, the only former employee to ask for his job back, stood at the door and greeted guests who were eager to see the former eyesore in its new incarnation. To celebrate the Redmont's transformation, Mayor Richard Arrington declared "Redmont Hotel Day" after an elaborate grand reopening.

A number of sports figures, musicians and celebrities have called the Redmont Hotel their "home away from home" over the years, including President George Bush, James Taylor and Bob Dylan's band. During the 1960s, Jim Folsom and George Wallace based their campaign headquarters at the Redmont when they were running for governor. Locals say that the Redmont's most famous guest, Hank Williams, may have never checked out.

Doors first opened at the historic Redmont in 1925.

On December 30, 1952, Hank Williams loaded up his 1952 Cadillac for a tour through West Virginia and Ohio. Hank's driver was a seventeen-year-old college student named Charles Carr. At 11:30 a.m., Hank drove off from his mother's boardinghouse wearing dark blue pants, a white button-up shirt, a tie and a navy blue overcoat. After driving to a local doctor's office and getting a shot of morphine to ease Hank's back pain, the pair set off for West Virginia on Highway 31, headed for Birmingham and Knoxville, Tennessee. Because of an impending snowstorm, Hank and Charles decided to spend the night in Birmingham's Redmont Hotel. No records of Hank's visit to the Redmont exist, but former employees believe that he stayed on the ninth floor. The pair had only been in their room for thirty minutes before there was a knock on the door. Three women invited themselves in and introduced themselves. Hank asked them where they were from, and one of the girls said, "Heaven." Hank is reported to have replied, "In that case, you're the very reason I'm goin' to hell." After the women left, Charles ordered meals from room service. Twenty-four hours later, Charles pulled into Burdette's Pure Gas and Oil Station in Mount Pleasant, Virginia, and found out that Hank had died in the back seat of the car sometime during the night. From 1952 until the hotel closed, several employees of the Redmont claimed that they had seen Hank's ghost standing in the hallway of one of the upper floors. He was usually dressed in his dark pants and white shirt.

The second ghost that is said to haunt the Redmont Hotel is the ghost of Clifford Stiles, who died in 1972. Many maids and clerks have seen him walking around the hotel over the years, usually in the vicinity of the penthouse. He seems to be checking up on the staff to make sure that the hotel is operating properly, just as he did when he was alive. Some guests claimed that they

had just walked into their rooms when they heard the door lock from the outside. When they opened the door, no one was in the hallway. After the guests reported the incident, they were jokingly told that it must have been the ghost of Clifford Stiles who did it. A few employees even reported seeing Stiles's ghost moving things around in the rooms.

Following its multimillion-dollar renovation, the Redmont Hotel has become one of Birmingham's finest hostelries. The rooms feature all of the modern conveniences, such as cable television, two-line speakerphones with data ports, complimentary broadband Internet access and a full in-room office. Some of the hotel's more lavish touches include a brightly lit vanity sink and full-length mirror. Guests can also take advantage of the hotel's fitness center and several small conference rooms. Casual and fine dining restaurants are located just down the street. The new owners have made every attempt to re-create the air of Old World elegance that made the Redmont Hotel a favorite stopping-off place during the Jazz Age. Some believe that the remodeling might also have stirred up the Redmont's resident ghosts.

THE SPIRITS OF SLOSS FURNACES

The Sloss Furnaces owe their existence to the rich mineral resources of Jones Valley and the vision of James Withers Sloss. Born in Limestone County in 1820, Sloss's business acumen first surfaced in 1835, when he began working as an accountant for a butcher. In 1842, he opened what was to become the first of a chain of mercantile stores in Athens, Alabama. By 1862, Sloss had invested heavily in railroads. After the Civil War, he took the

first step toward creating the transportation network required to tap the region's mineral wealth. He combined a number of short railroad lines to form a leg of the Louisville and Nashville rail line. Once the tracks had been extended south to Birmingham, the large-scale development of the region's coal and iron deposits became more than just a pipe dream.

In 1873, Sloss was instrumental in the formation of the Cooperative Experimental Coke and Iron Company, which used coke instead of charcoal to produce iron in the old Red Mountain Oxmoor Furnace. In 1880, Pratt helped form the Pratt Coal and Iron Company and began construction of the city's first blast furnace on fifty acres on the northern edge of Birmingham. The state-of-the art furnace was designed and built by Harry Hargreaves, who had studied under Thomas Whitewell, the inventor of the stoves that supplied the hot air blast for the furnaces. The first blast furnace was blown in 1882, the second in 1884. The furnaces were sixty feet high and eighteen feet in diameter. In its first year of operation, the newly christened Sloss Furnace Company produced twenty-four thousand tons of pig iron. The Louisville Exposition recognized the high quality of the foundry's iron by awarding it a bronze medal.

Following his retirement in 1886, Sloss sold his company to John W. Johnston and Forney Johnson. With the backing of Wall Street financier J.C. Maben, the two investors reorganized the foundry as the Sloss-Sheffield Steel and Iron Company in 1899. The firm's expansion plans included the construction of two more furnaces and three hundred ovens on the grounds of the newly acquired Coalburg Coal and Coke Company. After Maben became president of the firm, he installed new blowers in 1902 and new boilers in 1906. Between 1927 and 1931, the old furnaces were completely rebuilt. By 1939, the Sloss-Sheffied Steel and Iron Company had become one of the

chief southern suppliers of pig iron for pipe manufacture. A dehumidification plant was constructed during World War II to reduce the company's dependence on coke. The United States Pipe and Foundry Company purchased the foundry in 1952, but business was hampered by the introduction of plastic pipe and ductile iron, as well as the firm's increasing dependence on more expensive foreign ore. The Jim Walter Corporation acquired the company in 1969 but donated it to the Alabama State Fair Authority in 1971 with the intent of converting it into a museum. In 1977, Birmingham voters approved of a $3.3 million bond sale to stabilize two-thirds of the historic structures and to fund construction of a visitors' center. Today, Sloss Furnaces is the only twentieth-century blast furnace preserved as a historic site. In recent years, the nineteenth-century industrial complex has achieved a reputation as one of the most haunted historic places in the entire country.

One of the most fascinating aspects of the Sloss Furnaces is the archives, which preserve interviews with former employees, many of whom were black. Before James Sloss sold the furnaces, he employed as many as 565 African American males. In 1900, blacks composed 65 percent of the Birmingham iron and steel workforce and 75 percent in 1910. Subsequent owners of the City Furnaces depended so heavily on the cheap labor provided by African Americans that they saw no need to install labor-saving equipment until the 1920s, when thousands of black Alabamians migrated north in search of a better life and higher-paying jobs. The blacks who continued to work at the Sloss Furnaces until they closed for good in 1971 punched separate time clocks, bathed in separate bathhouses and attended separate company picnics. Job categories were segregated as well. Most of the supervisors, technicians and skilled workers were white; blacks constituted the entire "common labor" workforce.

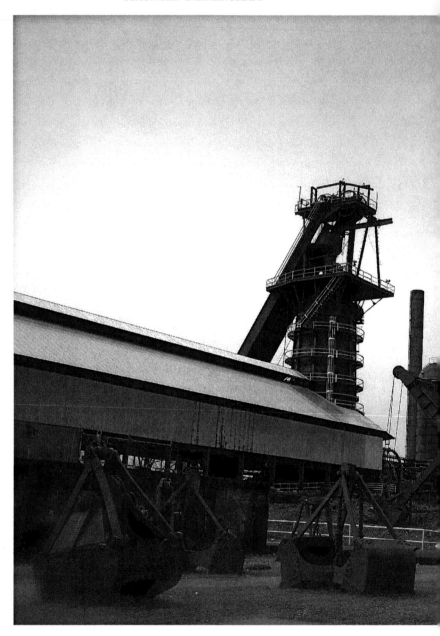

Sloss Furnaces.

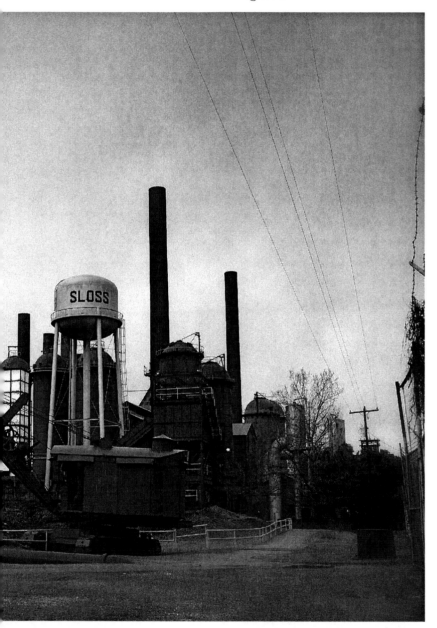

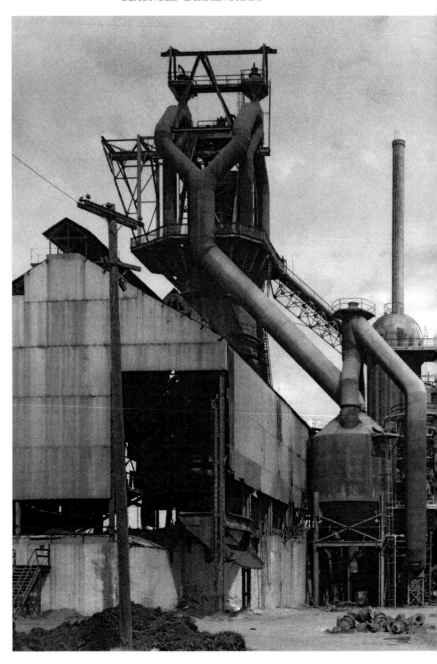

Sloss Furnaces. *Courtesy of the Library of Congress.*

Birmingham

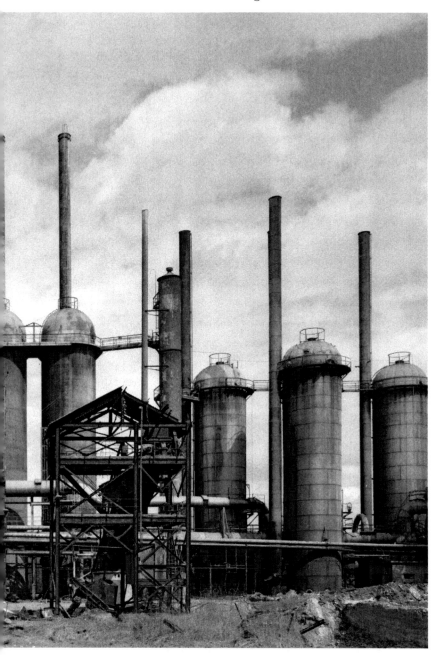

Not surprisingly, working in the Sloss Furnaces was perilous. For example, some work teams were required to load iron ore into the vertical hoists. Once the ore had been lifted to the top of the stacks, workers called "fillers" dumped the loads into the flaming furnaces. Because they had to maintain a fast pace, fillers who did not pay enough attention lost their footing and fell into the molten iron. Those fillers fortunate enough not to be incinerated ran the risk of dying from inhaling the noxious fumes emitted from the stacks, according to W. David Lewis's *Sloss Furnaces and the Rise of the Birmingham District.*

The casting sheds presented their own special hazards. The six- to eight-man work teams that used hammers, hand drills and crowbars to remove the clay plugs from the base of the furnaces were exposed to heat so intense that workers were rotated every few minutes. After the plug was finally chipped away, the men had to leap out of the way to prevent being burned by the stream of molten ore that gushed from the opening in the furnace. The men who guided the molten iron into the central trench and the smaller channels—or sows—also risked their lives on a daily basis. Laborers had to be vigilant for small amounts of moisture that would cause the molten iron to explode. To make matters worse, these workers were pressured to fill the sows and the pig iron molds very quickly, increasing the possibility of accidents. The workers who separated the simmering pigs from the sows almost always suffered from burns and blisters on their feet, despite the fact that they wore shoes with heavy wooden soles. Loading the cooled pigs into the mule-drawn tramcars was back-breaking work that eventually wore down even the strongest men after only a few years, wrote Lewis.

The exact number of people seriously injured or killed is unknown. However, history does record the horrible deaths of a few of these individuals. In late November 1882, two black

laborers, Aleck King and Bob Mayfield, were lowered on a platform inside the No. 1 furnace, where they were supposed to remove the deposits of coke and ore clinging to the inner walls. Using picks, the men were chipping away when suddenly a huge mass of congealed ore dislodged from the walls and plunged into the furnace, sending up clouds of gas and smoke. Choking uncontrollably from the toxic fumes, the men toppled from the platform and fell into the furnace.

A few days later, another laborer met his death in the fiery furnace. Samuel Cunningham was a transient worker who had just arrived from Kentucky. Like many mill employees, the strain of performing extremely dangerous tasks under deplorable conditions drove him into a state of depression. One day, he walked over to Alice No. 1, climbed the hoist to the top of the stack and jumped into the roaring furnace as his co-workers looked on in horror.

The best-known work-related death also produced the iron industry's most famous ghost story. Theophilus Calvin Jowers was a white supervisor who left his father's plantation near Widowee after the Civil War to seek his fortune in the burgeoning iron industry in Jones Valley. In 1870, he married Sarah Latham in Irondale, where he found employment at W.S. McElwain's Cahaba Iron Works. Eager to learn every face of iron making, Theophilus worked right alongside the black workers in the plant, converting hard wood into charcoal and preparing the sand molds that shaped the pigs. In 1873, Theophilus and Sarah left Irondale and moved to Oxmoor. Theophilus soon found work as assistant foundryman at the Eureka Mining and Transportation Company of the Oxmoor Furnaces. He was undoubtedly present when coke—a derivative of coal—was successfully used to make pig iron at Oxmoor on February 18, 1876.

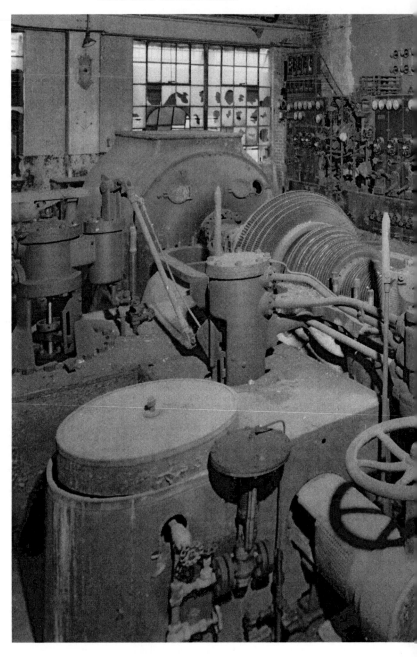

One of the many control rooms located within the Sloss Furnaces.
Courtesy of the Library of Congress.

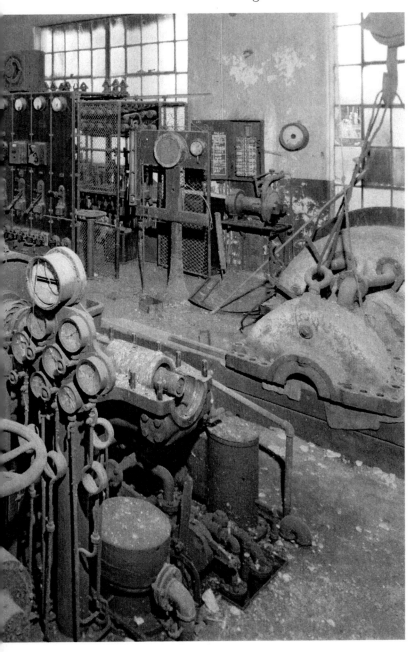

In the spring of 1887, Theophilus was offered the job of assistant foundryman at the Alice Furnace No. 1 in Birmingham. The offer was too good to refuse because it offered Theophilus, Sarah and their five children a chance to leave the stifling atmosphere of Oxmoor and move to Birmingham, which had become a bustling city. At the time, Alice No. 1 had set a record in the South for producing 150 pigs of iron in a single day. Theophilus realized when he took the job that he would be responsible for maintaining that same high level of productivity.

Theophilus had not worked at Alice No. 1 for very long before Sarah's worst fears came true. On September 10, 1887, Theophilus was directing a work team that had assumed the task of replacing the old bell with a new one. Theophilus had planned to hoist up the old bell and slowly lower it into the furnace to be melted down. He was holding the rope that was to release the bell when, all at once, he tripped, releasing his hold on the rope. The enormous bell plunged into the molten iron, and Theophilus fell on top of it. Within seconds, the molten ore covered his body, reducing it to ashes almost instantaneously. His co-workers used a piece of sheet iron attached to a piece of gas pipe to retrieve his remains, which consisted of only his head, bowels, two hipbones and a few ashes, according to Kathryn Tucker Windham's *The Ghost in the Sloss Furnaces*.

Sarah and her children were devastated by Theophilus's agonizing death, but they were saved from financial ruin because ironworkers took care of their own. Her late husband's co-workers pooled together their time and money to build a new house for Sarah and her children. The millworkers also bought the lunches that Sarah sold from her house. Theophilus's reputation as a hard worker and loyal friend served his family in good stead for many years after his death. Sarah soon learned that Theophilus's influence persisted in other ways as well. Not

long after Theophilus died, workers began reporting feeling surprisingly cold when they were on the bridge at Little Alice. Seconds later, they sensed that someone was standing nearby, watching them. When they turned to look, no one was there. Not long thereafter, workers preparing to charge the furnace claimed to have seen a figure walking around, almost as if he was supervising. Over the years, stories continued to be told of a male apparition that strode through the flying sparks and searing heat with impunity.

Over the next few decades, workers took seriously Theophilus's vow to his wife that "As long as there's a furnace standing in this country, I'll be there!" In 1905, after Alice No. 1 was dismantled, the ghost of Theophilus Jowers moved to Alice No. 2. For the next two decades, the spectral shape of the former assistant foundryman appeared in parts of the plant where no living human being could have survived the heat and flames. In 1927, when Alice No. 2 was abandoned, the ghost took up residence in the Sloss Furnaces on First Avenue. In her book *The Ghost in the Sloss Furnaces*, author Kathryn Tucker Windham tells of John Jowers's first encounter with his father's spirit.

He had just purchased a new 1927 Model T Ford, and he decided to take his son, Leonard, on a drive down First Avenue so that he could see the iron mill where his grandfather had worked. After the Model T crested the top of the viaduct when John stopped the engine, John took Leonard's hand and told him that they were going to take a close look at the furnaces. They were leaning over the metal railing of the viaduct, looking at the furnaces, when John saw a man walking through the scorching flames. He immediately directed his son's attention to the spot where his father's ghost appeared, but the ghost was gone. John saw his father's ghost on several other nights while leaning against the railing of the viaduct. For Theophilus Calvin

Jowers, it seems, working at the iron mill was much more than a lifetime calling.

A much lesser-known spirit also lives on in the folklore of the Sloss Furnaces. In the early 1900s, a young woman who had become pregnant out of wedlock walked unnoticed through the gates of the Sloss Furnaces. While the men were pouring the iron into the sows, she climbed up Alice No. 1 and jumped into the furnace. Ron Bates, a tour guide, said that the girl's spirit returned to Sloss Furnaces in a very unconventional form: "One day, city officials and plant managers were having some kind of official ceremony at Sloss Furnaces when all at once, a white deer ran through the crowd and disappeared. Some people believed that it was the reincarnation of the pregnant girl who killed herself in the furnace." Ron went on to say that the deer still appears whenever dignitaries visit the furnaces on special occasions.

A much more apocryphal story concerns a sadistic foreman named James "Slag" Wormwood, who supervised the graveyard shift in the early 1900s. Because he forced the 150 workers on his shift to take dangerous risks, 47 men died while he worked there. An untold number of workers suffered debilitating injuries that forced them to quit their jobs. In 1906, Wormwood was walking on top of the Big Alice furnace when he lost his footing and fell into the molten ore. Rumors quickly spread that it was not the fumes from the rising methane gases that had caused him to become disoriented and plummet into the furnace but the hands of one of his tormented workers who pushed him to his death. Over the next several decades, a number of sightings of Wormwood's ghost were reported. In 1926, a watchman was pushed from behind and told to "get back to work." In 1947, 3 workmen who were found unconscious in a small boiler room also claimed that a badly burned man ordered them to return

to work. In 1971, another watchman said that he was walking up the stairs when a demonlike figure pushed him from behind. The entity then began beating the man as he was lying on the stairs. To this day, tourists occasionally report feeling a pair on unseen hands on their backs, especially on the catwalk.

Despite Sloss Furnaces' reputation as being one of the most haunted places in the United States, no formal investigations were conducted until 2005, when Ghost Chasers, International, from Bardstown, Kentucky, became the first group to visit the mill. The truth behind the ghost stories became immediately apparent. Chuck Starr, the husband of the director of Ghost Chasers International, Patti Starr, said, "When we first walked into the factory," Patti looked up at the water tower and saw a man walking on the catwalk. Back in the museum, Patti described the apparition to one of the tour guides, who told her that the ghost of a man on the water tower is frequently sighted at the mill.

More paranormal activity was detected down in a man-made waterway that served as a cooling system. The waterway is between two and three feet wide and approximately eight inches deep. Chuck said, "When we were down there, we could hear whispering behind us. It was very clear." Unfortunately, the group was unable to record the sounds because of the noise made by the rushing water.

Ghost Chasers, International, also picked up some startling EVPs (electronic voice phenomenon) that night. One of these was the voice of a little girl who said, "Hi, Daddy. Here's your lunch." "Patti was really confused," Chuck said, "because she wondered why she was picking up a child in an old factory." The group's tour guide from the museum cleared up the mystery: "The workers had homes right on the property, and that's where they were living. There were five hundred workers on a shift,

The blowing engine building, 1902.

and the children and their mothers would bring their lunches to them during their lunch and dinner break."

Chuck said that nationally known psychic Chip Coffey accompanied the group. Chip had just completed Patti's ghost hunting course, and he was eager to apply what he had learned to a genuine investigation. Ironically, the newest investigator had the closest personal experience that night when the group entered the factory portion of the mill. Chip had just sat down when he began feeling the presence of a man who had been injured on the job many years before. "I don't get the impression that he lost his life," Chip said, "just a limb." Chip had no sooner lost contact with the entity than one of the investigators noticed blood on Chip's hands. "We checked him over pretty carefully," Chuck said, "and there was no blood or abrasions anywhere on his skin." Chip does not know when the blood first appeared on his hands because he was not paying attention. Fortunately, the group was able to capture the blood on Chip's hands on video.

Birmingham

On September 14, 2007, the Oxford Paranormal Society (OPS) conducted an investigation at Sloss Furnaces. The OPS was accompanied by a reporter and two photographers from the *Birmingham News*. The members placed four stationary infrared cameras to cover the catwalks and the entrances and exits. Members of the team also carried around four handheld infrared cameras as they walked through the structure. The team split off into three groups: one group remained at the monitoring station; one group sat still and recorded EVPs; and one group walked the grounds. The investigation ended at 3:00 p.m. The teams captured no visual images, but they did collect some interesting EVPs. One group recorded a voice near the plaque of Theophilus Jowers. Three of the questions asked by another group were answered by a loud banging sound.

Another paranormal research group—GHOUL from Alabama—investigated the Sloss Furnaces during the daytime in May 2008. Bob Giordano, the director of the group, said that the members were exploring the main tunnel when Bob asked the question, "Can you give us a sign of your presence?" About two minutes after Bob asked the question, someone—or something—threw a handful of pebbles as him. "They hit me in the back of the leg," Bob said. "We were recording EVPs at the time, and when we listened to the tape we heard the pebbles being picked up and thrown at me, but we also heard two big rocks hit the wall. We hadn't heard the sound of the big rocks until we listened to the recording." Another team that was walking through the same tunnel was taking photographs at the end of the tunnel. "One of the members caught what seems to be the shadowy image of a little girl," Bob said. "She's holding her arm out like she's carrying something, but you don't see anything in her hand. It was definitely a full-bodied apparition."

The members of GHOUL heard some very unnerving sounds during the May investigation as well. Bob remembered, "There were three investigators walking through the boiler room, and they heard a woman say something, but they couldn't quite make out what it was. They were doing EVP work at the time, but they didn't record anything. All three investigators insisted that they heard the same disembodied female voice at the same time." One of Bob's lead investigators was recording EVPs outside of the boiler room in the vicinity of the smokestacks when he and the other members of his team began hearing footsteps coming toward them. After the footsteps stopped, the members asked the entity, "What is your name?" Suddenly, they heard the footsteps again. This time, they came even closer to the team before stopping altogether. However, the sound did not appear on the recorder. Several of the investigators from another team working inside the boiler room had just detected the scent of burned oil when they began hearing the machinery start up. Once again, though, the group did not record the sound. "That's one thing we have noticed at Sloss Furnaces," Bob said. "Sounds that we hear with our ears do not show up on the recorder."

Bob's wife had the most startling personal experience in the May investigation. Bob and another investigator were up on the catwalk in the boiler room while his wife was sitting down. Suddenly, she shouted up to the men that she was beginning to feel cold. At that moment, Bob took her photograph. When they examined the photograph, they were amazed to see the image of a dog. "It was standing on its hind legs, looking at my wife. You can clearly see its tail, too. She didn't feel the dog, though, just the cold," Bob said.

GHOUL returned to the Sloss Furnaces in July 2008. Bob Giordano said that he and his members stayed in the old plant from 6:00 p.m. until 3:00 a.m. "One of our teams was in the

boiler room taking pictures," Bob said. "When we reviewed the pictures later on, we caught the image of a man on fire in two photographs. One picture shows a profile view of the man, and in the other, he is staring directly at the camera." A team that was working around one of the towers took another photograph of a black figure working at a panel. While the group was doing EVP work down in the waterway, one of the members of the group aimed his camera over Bob's shoulder and took a photograph of the head and shoulders of a man hovering over the water. The group also captured a large number of orbs on film, but because of the high concentration of dust in many of the rooms, the photographs could not be submitted as evidence of the paranormal.

GHOUL's third investigation of Sloss Furnaces was conducted on January 8, 2009, from noon until 4:00 p.m. "We had two groups from Georgia investigating with us," Bob said. "We got video of some shadows moving around the basement of the boiler room. It was strange because there was nobody else around. We were looking down the room in the back of the basement, and in the background, you can see the pipes and a shadow walking by. There was nobody down there." One member who was walking through the boiler room began feeling dizzy. She also sensed the presence of another person. At this point, the investigator realized that she had to leave the boiler room as quickly as possible.

Four other members who were in the tunnel had an experience very similar to that of the investigator in the boiler room. "They got the feeling that they were being surrounded and watched," Bob said. "And then all of a sudden, all four of them started getting headaches and [feeling] dizzy, so all four of them got out of the tunnel. When they got out, they started feeling better. They said that something definitely was down there with them."

Investigators are not the only ones who encounter the ghosts of Sloss Furnaces these days. Workers and visitors often feel as if they are being watched by an invisible presence. People walking along the catwalk in the boiler room during tours have reported a glowing, humanoid shape lurking around. Ron Bates says that the most haunted building is the blowing engine building. Built in 1902, it is the oldest building still standing at Sloss Furnaces. Workers who had set objects down in one part of the building have found them moved to another room later on. Doors open and close by themselves in the blowing engine building as well. Ron occasionally sees the shape of a person in the blowing engine building out of the corner of his eye, but it always vanishes when he turns around for a better look. "Visitors see the shadowy figure of a man all the time," Ron says, "but it could be one of our maintenance men." When one considers all of the pain and suffering that was endured by workers at Sloss Furnaces for almost a century, the possibility that the old mill might be haunted is not really that far-fetched.

THE SWORD IN THE TREE AT ARLINGTON

Arlington is one of the few antebellum homes in the Birmingham area. According to many sources, Arlington was built by William Mudd in 1842. However, a former director of Arlington, Mrs. Catherine M. Lackmon, believes that the first wing of the house was built about twenty years later by Stephen Hall, who purchased 475 acres on April 21, 1821, near the town of Elyton. Hall's will mentions a "dwelling house and outhouses thereunto belong," which were probably constructed in 1822. The house stood on a wooded knoll just

off the old Georgia Road. Hall, a cotton planter, became one of the wealthiest men in the county. However, by 1842, Hall had accumulated so much debt that in 1842, the land was sold at public auction in front of the courthouse of Jefferson County in Elyton to an attorney, William S. Mudd, for $700. Four years later, he bought a neighboring tract of 80 acres. Instead of tearing down the existing house and starting over, Mudd added the east wing, copying the architectural style of the west wing. Mudd's intention was to create a colonnaded mansion for his new bride. Mudd, who eventually became a judge, enjoyed receiving guests at his lavish new home. Before Long, Mudd's home became the social hub of Elyton's social set.

However, on March 28, 1865, Mudd was forced to play the role of reluctant host when Wilson's Raiders, 13,500 strong, entered Elyton. During his two-hour stay in what he described as a "poor, insignificant Southern village," Union general James Harrison Wilson commandeered Mudd's home for his headquarters. The general and his staff resided on the first floor while Mudd, his wife and his four daughters stayed upstairs. From Arlington's luxurious sitting room, he ordered his Raiders to destroy munitions, factories and the University of Alabama. Mudd was entertaining the poet Mary Gordon Duffee when Wilson's troops made their unexpected arrival. Duffee was leading a double life as a newspaper reporter and a Confederate spy. To keep her safe from the Yankee intruders, Mudd hid her in the attic. When she overheard the general's plans to destroy the iron furnaces at Tannehill, Duffee sneaked out of the attic in the dead of night so that she could warn the workers of the impending invasion. Ironically, the unwelcome visit by Wilson's Raiders probably saved the mansion from destruction. After the Civil War, Colonel James Powell, Josiah Morris and John Milner sipped brandy and smoked cigars at Mudd's home while

Arlington.

planning the creation of a new town just east of Elyton to be called Birmingham.

After the Civil War, descendants of the Mudd family moved to Birmingham. The size of the estate dwindled over the years. Following Mudd's death in 1884, ownership of the house changed hands several times. The Mudd family sold the house to Henry Bardleben, a Birmingham entrepreneur, who sold off all but thirty-three acres before finally deeding the land over to Franklin H. Whitney of Iowa. Whitney divided the property up into lots and rechristened it as Arlington Survey in honor of his idol, General Robert E. Lee. Under Whitney's ownership, Arlington was inhabited around the turn of the century by a German immigrant family and a black newspaper editor and his wife, who lived in a frame house in the front yard.

After Whitney died in 1896, Arlington passed into the hands of Robert Sylvester Munger in 1902. Munger was a Texas philanthropist who had amassed a fortune for inventing a method of removing harmful lint thrown off during the cleaning

of cottonseed in the ginning process. By the time Munger had become the new owner, Arlington was in serious need of repair. He not only renovated the house, but he also added such modern conveniences as indoor plumbing, central heat and electricity. Arlington served as the Munger family's summer retreat until 1910, when they made the home their permanent residence.

After Munger died in 1924, his daughter, Ruby Montgomery, and her husband, Alex, inherited the house and property. By this time, the estate had been reduced to only six acres. In 1951, the Montgomerys decided that Arlington was not a suitable residence for only two people, and they decided to convert the property into a subdivision. Convinced that Arlington should be transformed into a shrine instead, a group called the Birmingham Historic Committee initiated a campaign to raise funds to save the old mansion. Individuals, business firms and almost every civic group in Birmingham donated money to the campaign. By 1953, the Birmingham Historic Committee had raised $25,000 toward the $50,000 purchase price. The City of Birmingham added another $25,000 and agreed to underwrite the mansion's operation costs, which would be offset in part by an admission charge once guided tours were offered in the home.

Since Arlington was first opened to the public in 1953, the Arlington Historical Association has tried to restore the mansion to the way it would have looked between 1842 and 1875. A number of individuals have donated period furnishings, such as an Empire sofa and an ebony square grand piano, circa 1840; two Enfield rifles, 1862–63; a mahogany Hepplewhite banquet table inlaid with light-colored satinwood, 1780; and a Sheraton sideboard with serpentine front, 1810. In 1985, the Arlington Historical Association raised $70,000 to renovate the old mansion. Chips of paint were analyzed to determine the home's original color, which turned out to be a creamy white. Layers of

bricks on Arlington's four chimneys were stabilized with the help of the city's Traffic-Engineering Department. Shutter workers patented by Frank B. Mallory of Orange, New Jersey, in 1886 were cleaned and repaired. Workers also replastered the walls and replaced sections of the wooden handrail on the central staircase that had rotted. The outdoor kitchen was transformed into the gift shop.

Like many antebellum homes in the South, Arlington has a storied past. Elderly residents of Birmingham still talk about seeing a Civil War saber sticking out of an ancient oak that stood in front of Arlington, the city's only remaining antebellum mansion. According to the legend, a young woman who lived at Arlington fell in love with a young man from a neighboring plantation. They were engaged to be married, but like so many young couples in 1861, they decided to postpone their wedding until the war ended. Just before leaving with his regiment, the young man was saying goodbye to his sweetheart beneath the shade of a young oak tree. Desperate to prove his undying love, he thrust his sword through the tree trunk and vowed to remove it upon his safe return. Like so many young soldiers eager to prove themselves in battle, the young man died, and his fiancée refused to allow the sword to be removed from the tree. Over the years, the tree grew around the sword, leaving only its hilt and tip visible. One could still see the sword protruding from the tree well into the twentieth century. This romantic story bears a strong resemblance to similar Civil War legends collected throughout the South. However, Birmingham's version of the story is much more than just a fanciful tale. In fact, the true story of the sword in the tree is almost as unbelievable as the legend itself.

Although I had heard the legend of the sword in the tree for many years, my interest in the legend was revived in June 2002.

Birmingham

While speaking to a group of senior citizens at St. Martin's in the Pines, I learned that the story is true and that the sword is on display in the parlor. In July, I visited Arlington and was surprised to find that the "sword" mounted to the wall of the parlor was not a sword at all but the blade of a scythe. Food services supervisor Stephen R. Moode gave me the true account of Arlington's most enduring legend:

> *This is the version I have heard. As you can tell, it's not really a sword. It's a scythe. At the time of the Civil War, there was another plantation over by legion field. One of the soldiers in Elyton who was going to war pledged his love to the girl who lived there. He told her he'd love her forever. Just before his company marched off to war, he picked up a scythe and shoved it through a little oak tree. He told the girl, "As long as this sword stays in the tree, I will love you." Of course, he got killed in the war, and she never pulled the scythe out.*

Steve went on to say that over time, the handle of the scythe eventually rotted off, leaving only the rusted blade in the tree. In the 1960s, during the construction of an apartment, the old oak tree was cut down, and the chunk of wood containing the scythe blade was taken to Arlington. After the wood rotted away, the scythe disappeared. Steve said,

> *We couldn't find it anywhere. Then four years ago when we were remodeling the house, I was on a ladder in the front parlor. I was up on the ladder, and I looked down—and guess where the scythe was. It was on top of the secretary. It has a very deep crown, and nobody could ever see it. I brought the scythe into the dining room where we were having our Thursday luncheon. I went up to our director and said,*

The infamous Arlington "tree sword."

"Dan, I hate to bother you, but I've got something to show you. Is this what you've been looking for?" He said, "Oh, my! Let me see it!" He added that the staff members at Arlington had been looking for that thing for many years. The scythe had probably been put there back in the late 1970s or the early 1980s. No one really knows why.

Apparently, the fate of the "sword" in the tree is not the only mystery that has been generated at the antebellum home. In

recent years, guests and staff members have reported a number of seemingly paranormal incidents in the home. Guests have seen rocking chairs move by themselves, as if someone is sitting in them. Docents have heard doors slamming in the house on days when no one else was present. Some people have also felt as if they are being watched by "unseen" eyes. The identity of the ghost has never been determined, probably because so many different families have lived in the house over the years. However, a likely candidate would be the spirit of the girl whose lover was killed in the Civil War before he could remove the scythe from the tree.

The story of the sword in the tree, along with the mystery of its disappearance, is a good example of a traveling legend. In the version still circulating in Birmingham, Arlington was the setting of the lovers' farewell, and the rather utilitarian scythe has been replaced by the much more glamorous sword. Convincing the citizens of Birmingham that the "old" version of the story is false would probably be just as difficult as filling in all the blanks in the historical account.

COLUMBIANA

COLUMBIANA'S HAUNTED COURTHOUSE

The first courthouse in Shelby County was originally a schoolhouse. The present courthouse was built in 1854. Miraculously, it was spared by Wilson's Raiders when they destroyed the Shelby Ironworks during the Civil War. It was used as a courthouse until 1906, when work began on a new courthouse. The Old Shelby County Courthouse was sold on the courthouse steps to the highest bidder, Mr. J.W. Blackerby, for about $2,500. The building was used as a hotel/boardinghouse until 1934. It then housed a doctor's office and the public library upstairs. Sandy, one of the volunteers at the Old Shelby Courthouse, says that a number of people in town believe that it was once a funeral home. "Actually, the funeral home was in the building behind us," Sandy said. "People still come in, though, and tell us, 'Uncle Fred was laid out over there.' We don't have any records stating that it was a funeral home." In the 1960s, the building was used as city hall. In the late 1960s, the city council considered tearing down the dilapidated old building. It was saved from the wrecking ball by

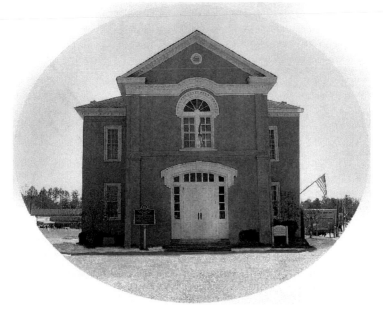

The Old Shelby County Courthouse in Columbiana is now home to the Shelby County Historical Society Museum and Archives. *Courtesy of the Shelby County Historical Society.*

only one vote. In 1972, the Shelby County Historical Society took over the courthouse and restored it. In 1974, it was listed on the National Register of Historic Places. Since 1982, the Old Shelby County Courthouse has housed the Shelby County Museum and Archives, which contains records and artifacts from the Indian era through World War II. Some workers at the museum say that the old courthouse is also home to a ghost.

The ghost that haunts the Old Shelby Courthouse is said to be the spirit of a man who killed himself upstairs in the front room. "This must have been after 1881," Sandy said, "because the front part and the back part of the building weren't added until after 1881. No one knows who the man was." People suspected that the courthouse was haunted when they began hearing knocking

in the upstairs kitchen and bathroom. Usually, the knocking in the bathroom seems to come from the outside of a door that was sealed off. Several years ago, a couple of workers were upstairs at night, and they both saw a spectral figure out of the corner of their eyes. Sandy has witnessed the ghost's handiwork herself: "He has a tendency to leave the shades open. I had been working here for a couple of months. I went upstairs, and one of the blinds was open about three inches. I just acknowledged, 'You're here. If you leave me alone, I'll leave you alone.' I lowered the shades down and went back downstairs. That's how he tells us he's here. Most of the time, he doesn't bother anything." Despite the possibility that she might be sharing the old building with a being from the "other side," Sandy insists that she has never felt scared since she started working there.

Bobby Seale, the director of the Old Shelby County Courthouse, says that he does not believe in ghosts but he has had some experiences inside the building that he can't explain. "I work sometimes until ten o'clock at night," he said, "and I can walk into the Christian-Davis Room on the first floor and go over to the far wall, and I feel like somebody's staring at me. Also, I used to have an awful time in this room with the pictures on the wall being crooked. I'd straighten them, and the next morning, they'd be crooked again." Mr. Seale experienced something strange in the Johnston Room—also known as the "Ghost Room"—upstairs. "This is the room where we have trouble with the blinds. One night, I was here by myself, and I went upstairs to the Ghost Room where the prisoner hanged himself, and the blinds were raised halfway up. We had a ghost hunting group come in here one night, and they took video of the blinds going up by themselves." If ghosts are indeed real, Mr. Seale believes he knows why one or more spirits haunt the old courthouse: "We were given some coal cars from the Civil War

Staff has trouble keeping the pictures in the Christian-Davis Room from hanging crooked.

Blinds have a tendency to raise themselves in the Johnston Room.

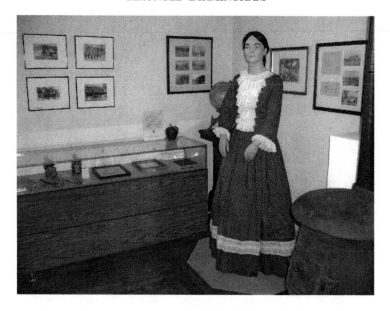

The Johnston Room is haunted by the ghost of a prisoner who hanged himself there.

era. The coal cars were pulled by slaves. It could be that bringing the coal cars in here had something to do with the haunting of the building. I just don't know."

Today, the Old Shelby County Courthouse houses the largest genealogy department in Shelby County. In the late 1970s and early 1980s, records that were being stored in attics and outbuildings were recovered and indexed. Visitors interested in tracing their families' roots can peruse wills dating back to 1818, marriage records dating back to 1824, newspapers dating back to 1866, chancery and circuit court records, deed books through 1899, census records from 1820 through 1930 and the Confederate pension applications. They might also learn something about the ghost who occasionally disrupts the tranquility of the old building.

JASPER

THE FACE ON THE DOOR

The image of the face of Jesus Christ has appeared on objects for centuries. The term "acheropite," meaning "not created by human hands," was first applied to the Shroud of Turin and the Veil of Veronica. Down through the years, the face of Jesus Christ has also been detected in photographs, food, trees, glass, reflections and other objects. In 1978, Maria Rubio of New Mexico was preparing to eat a burrito when she noticed the face of Jesus staring up at her. In 2003, the face of Jesus is said to have appeared in her unborn son's echogram, taken when she was thirty weeks pregnant. She interpreted the mysterious image as a sign that she should not lose hope of having a baby after several miscarriages. In 2005, Jeff Rigo from Pittsburgh sold an image of Jesus on his bathroom wall for $2,000. In 2008, Michael Cartwright, a thirty-five-year-old cab driver, was sitting in a pub in England. After the waiter popped open a bottle of apple cider, Cartwright was shocked to see the face of Jesus in the aluminum on the neck of the bottle. Residents of Jasper, Alabama, say that in 1983, the face of Jesus appeared on the door of a room in the Walker Baptist Medical Center.

The April 13, 1983 edition of the *Daily Mountain Eagle* carried a story about sixteen-year-old Ray Naramore, who was severely injured in a motorcycle accident. The boy was taken immediately to what was then known as Walker Regional Medical Center, but his temperature was so low that the boy was not expected to live. After the doctors informed Ray's father, Joel, that his son's prognosis was not promising, the grief-stricken man sat in a chair outside of the room, thinking about how much he loved his son. A short while later, he happened to look up and was amazed to see the face of Jesus Christ on the door. All of a sudden, Joel realized that his son was going to be all right. Later that day, the boy's condition improved so much that he was transferred to Birmingham, where he made a full recovery.

Hazel H. Cooksey, a member of the Senior Services Division of the Walker Regional Medical Center, recalled the public's reaction to the face on the door: "They had the story on [the television show] *That's Incredible* a few years ago. After the show aired, so many people came to see the face of Jesus that they had to put Plexiglas over the door to protect it. Over a thousand people lined up outside of the hospital to see the door. One man even wanted to buy the door. They have since moved the door to the hospital chapel."

I traveled to Jasper and viewed the door on July 29, 1993, and I must admit that I had no trouble making out the features of the face of Jesus Christ on the chapel door. Of course, I knew about the door before I visited the hospital, and I am a Christian to boot, so the powers of suggestion might have colored my vision. I am not surprised, though, that not everyone who has looked at the door sees the face of Jesus Christ in the grain of the wood. Psychologists use the term "pareidolia" to refer to the oversensitivity of the human mind to perceive the pattern of the human face in random phenomena. However, C.S. Lewis,

author of *The Lion, the Witch, and the Wardrobe*, believed that the perception of religious imagery reflects the religious reality that the world actually contains such beings. People, Lewis asserted, are wired to believe, not only in religion but also in the existence of religious imagery. One wonders, however, if the appearance of the likeness of Jesus Christ on the door is not so much an instinctive response to the dark swirls and whorls in the wood as it is a reflection of our need to cling to hope, even when logic suggests that hope is unwarranted.

JASPER'S HAUNTED RADIO STATION

On November 2, 1946, radio station WIXI began broadcasting with 250 watts of power as WWWB. It was the first licensed radio station in Jasper, Alabama. The station was owned and operated by Bankhead Broadcasting Company, Inc. The station took its call letters from the initials of Bankhead Broadcasting Company owner "Wonderful Walter Will Bankhead." Locals and people in the business referred to the station as simply "3WB." In 1955, the station received permission from the FCC to move to the current kHz broadcast frequency and increase its signal power to 1,000 watts. The station moved in 1975 to a house at 409 Ninth Avenue in Jasper. In March 1986, Tr-W Broadcasting, Inc., agreed to sell WWWB to SIS Sound, Inc. On October 10, 1988, the FCC changed the station's original call letters—WWWB—to WZPQ. In July 1999, SIS Sound, Inc., sold WZPQ to James T. Lee for $100,000. On June 6, 2005, the station's call letters were changed once again, this time to WIXI. In June 2008, Walker Broadcasting transferred WIXI back to James Lee for the forgiveness of a debt. Finally, WIXI was sold

Radio station WZPQ, Jasper.

by James T. Lee to Snavely Broadcasting Company LLC on September 9, 2008, for $199,500. Despite the station's name changes and changes of ownership, it has remained at the same location since 1975. Apparently, the late owner of the house, George Vines, has remained there as well.

George Vines was a Mercury dealer in Jasper in the 1950s. He also owned two drive-in movie theatres, one in Jasper and another in Tupelo, Mississippi. In the mid-1950s, George began building a home for his wife and daughter, Georgette. The home's Georgian marble exterior distinguished it from all of the other homes in the neighborhood. George Vines died in 1956, shortly after moving into his dream home. His body lay in state in the bay window in the northernmost room of the house.

George's wife and daughter began experiencing paranormal activity in the house shortly after his death. They began hearing someone dump coins on a table by the back door, just as George had done every night after coming home from the movie theatre.

Jasper

They also discovered cold spots in the room where George had lain in state. The family found it impossible to warm up these areas, even with electric and gas heaters.

The paranormal activity in the house continued after it became a radio station. Employees reported hearing coins tossed on the table by the back door. People who sat in the sales office near the bay window where George's body had lain in state found it extremely difficult to keep warm. Some people also felt cold breezes wafting through the building when the air conditioner was not turned on. One female employee distinctly recalls feeling her hair being stroked by an invisible hand. She also heard doors open and close when she was alone in the station. A former disc jockey at the station, Barry Patilla, said that on several occasions, he turned off all the lights, and as he was pulling out of the parking lot, the lights turned themselves back on.

Pamela Decker, a mass communications major at Walker College who worked at WZPQ in 1992, had a number of bone-chilling experiences in the radio station. Pamela saw the ghost of George Vines twice—in the doorway of the former control room and in the kitchen window overlooking the parking lot—but only in her peripheral vision.

> George walked swiftly past the control room, swinging his arms. He would reach inside the control room and pat the door as if to say, "Hello." Many times, I was on the air, preoccupied with a live microphone, and he leaned his head inside the doorway. Out of the corner of my eye, I saw a man's face and his hand grasping the door facing. If I did not immediately acknowledge him, he would pat the door facing a couple of times. As I quickly turned my head to look at him, he pulled away. What I saw appeared to be a full-bodied, flesh-and-blood person, not a shadowy apparition.

93

This always alarmed me because I knew I was there alone with the doors locked.

As soon as Pamela was off the air, she walked through the entire station to see if anyone else was in the building, but she was always alone.

Later that year, Pamela Decker's sister had a ghostly encounter that she was totally unaware of. "It was about 5:00 p.m., and she was alone in the station. All of the lights were out except for the control room lights," Pamela said. "She saw a man standing behind her in the control room and thought it was her boss training her or observing her work." When Pamela's sister noticed that there were no cars in the parking lot, shivers rose up her spine. "It puzzled and frightened her," Pamela said, "but she did not share this with me until several months later when I began working later shifts in August 1992. She had confided in our mother immediately after it happened, and they both worried about me being there alone because it was dark and scary."

Pamela also recalls hearing a number of strange noises when she worked in the station by herself:

I would hear the squeaking of someone's shoes when they walked by. Many times when I worked evenings, late nights and weekends alone, I would hear the back door open and shut, the aluminum blinds on the back door rattle against the plate glass and the first two floorboards creaking as if someone were stepping on them. When opened, the door made a distinctive sweeping sound as it brushed over the high pile carpeting. Also, the doorknob would rattle [as if someone was walking] into our lobby. I always locked the doorknob and chain-locked the door, so it was impossible to open it from

the inside. Each time this would happen, I would get up from the DJ chair and walk into the lobby to see who was there. Of course, no one ever was. If I did not get up to see who it was, I would see this figure "walk" by the control room. Sometimes, the production studio door would shut or open by itself, the toilet would flush by itself and I would even hear the lid lift up, all while I was alone.

Because Pamela heard someone lift up the lid to the toilet, she is fairly certain that the ghost haunting the station is male.

Pamela also had problems with the lights, just as Barry Patilla had: "Before leaving for the night, we had a checklist of things to turn off before we left. We had to turn off all the lights in the station except for a fluorescent light in the kitchen. All equipment was to be powered off, including the transmitter. Many times, when I would be pulling out of the parking lot, I would look back, and the lights would still be on."

I visited radio station WIXI in October 2007. I was being featured in a short segment on the ghosts that was going to air on BCS 42 WIAT-TV in Birmingham. As I was waiting for the equipment to be set up, I talked to a number of people at the station, which now broadcasts gospel music. Everyone I spoke to had experiences similar to Pamela's. One of the disc jockeys, Joe Bryan, said, "When we're on the air, with the microphone and the controller, we're looking out the bay window. Your back is to the rest of the studio. There have been a few times that I just knew someone was standing behind me."

Most new employees at WIXI enjoy working in a haunted radio station, once they discover that the entity is not going to hurt them. Pamela Decker was clearly not a believer in ghosts until she began working at WZPQ. The fact that other employees at the station had the same experiences she did convinced her

that the ghost was not simply a figment of her imagination. After talking to members of George's family, Pamela thinks she knows why George took such an interest in her: "He was a big flirt and had a great personality. They theorized that he appeared to me more than anyone else because he was flirting."

WALKER COLLEGE

Walker College opened its doors on September 15, 1938. In its first semester of operation, the student body consisted of only forty-five students. The school's first president was Dr. Carl Jesse. In 1956, when David Rowland became president of Walker College following the death of Dr. Jesse in 1955, the school had only thirty-four students and one building, Davis Hall. When Dr. Rowland retired in 1988, the college had more than nine hundred students. It had also acquired forty acres of land. In 1998, Walker College became the fourth campus to merge with Bevill State Community College. Today, the Jasper campus is said to be the most haunted of Bevill State's four campuses.

Most of the strange occurrences at the Jasper branch of Bevill State Community College have been reported in the oldest building on campus, Davis Hall. Many students believe that the building is haunted by the spirit of Dr. Carl Jesse. When Dr. Jesse died in 1955, his body lay in state in the auditorium on the second floor of the building. With the aid of a federal grant, Davis Hall was renovated in 1992 to house the broadcasting and journalism department. On the top floor of the building were a television studio, radio studio and journalism computer lab. During the fall semester of 1992, three professors and fifteen mass communications students had classes in the building, along

Jasper

Davis Hall, on the campus of Walker College, now known as Bevill State Community College.

with approximately one hundred students in the continuing education program. A member of the first group of students to have classes in the newly renovated building was Pamela Decker. Almost immediately, the students and faculty sensed that they were sharing the building with an otherworldly presence: "We heard phantom footsteps behind us and saw shadows as we walked through the halls and stairwells. Elevators would run by themselves. When the doors would open, no one would get off them." For a long while, though, the students kept their experiences to themselves. Pamela said,

> *When all these strange things began happening, we were pretty passive about them. We didn't discuss them for a long time. No one wanted to face the almost certain ridicule. But when we finally did have a group discussion, it turned out that almost everyone who'd been in the building had experienced*

something strange. Most of our encounters paralleled (seeing shadows, feeling a presence, hearing footsteps behind us, etc.). I believe everyone who'd seen, heard or felt something strange in Davis Hall was eager to tell someone, but because we were in a setting of higher education, we assumed that...the thought of "ghouls" or "spooks" would be out of place. Once the topic of a possible ghost came up, there was a feeling of release, a catharsis, I suppose.

As time passed, the paranormal activity inside Davis Hall escalated. Sheet music flew off music stands in rooms where the vents and windows were closed. Occasionally, students caught a glimpse of moving shadows in rooms where the windows had been blacked out. The state-of-the-art recorders, radios phonographs and amplifiers that had just been purchased for the department turned on and off by themselves. "All of the wiring had been newly done by certified professionals," Pamela said.

One of the scariest places in the building was the basement. Pamela said,

If you went to the vending area in the basement, you soon learned not to go alone. Many times, I could feel a presence and see shadows out of the corner of my eye. One day, I was standing at the vending machines in the basement when I saw someone walk by. I thought it was a maintenance worker or janitor. I began talking to the person, but I was met with silence. Puzzled, I walked back to the area [where] I saw the person walking toward. All the doors were locked, and no one else was in the basement. There were also several occasions when I could hear my name whispered ever so faintly.

Jasper

On several occasions, Pamela felt the presence of someone standing behind her on the stairwell. When she looked back, she was surprised to find that she was alone. "Or at least no bodily presence was there," Pamela said.

After a few months, Pamela and the other students in Davis Hall became somewhat accustomed to all of the weird activity in the building. Eventually, Pamela and the other students were envied by the other students in the school because of their strange encounters. "Soon, word leaked around campus about the haunting, and it became the talk of the school," Pamela said. "We were all considered 'pretty cool' to have classes with a ghost." As Davis Hall's haunted reputation became better known, the number of sightings increased. Pamela said,

> *Several students, including the college's honor students, heard strange noises, not only inside, but also just outside the building on the adjoining grounds. Many people who were skeptical before or just straight-out non-believers in ghostly phenomena changed their minds very quickly. Seeing or hearing for yourself does have that effect on people.*

Interest in the ghosts in Davis Hall was so high, in fact, that a story about the strange happenings in Davis Hall appeared in the 1993 edition of Walker College's yearbook, *Stars and Bars*. "It was written by one of my journalism classmates, whose opinion quickly changed about ghosts," Pamela said. The article recounted several encounters with the ghost in the building, including communication teacher Michael Silbergleid's problems with the equipment. The author, journalism student Josh Bean, wrote,

> *He* [Silbergleid] *said that he had seen brand-new T.V. cameras shut off for no reason in the T.V. studio and*

*mysteriously come back to life after a few minutes. There
is no explanation for this phenomenon. He contends that
absolutely nothing was wrong with the cameras. The ghost is
rumored to be the reason that Silbergleid left the college.*

Pamela Decker and other students who have had encounters
in Davis Hall believe the remodeling of Davis Hall awakened Dr.
Carl Jesse's dormant spirit. "He seemed to want nothing more
than to gain acknowledgment from the building's occupants. He
certainly did let us know of his presence!" Pamela said.

Today, the Jasper campus of Bevill State Community College,
along with its three sister campuses and two instructional sites in
Carrollton and Mount Olive, offers educational opportunities
to over a quarter-million people in a seven-county area. If the
eyewitnesses can be believed, the Jasper campus offers much
more than just a college degree. The school gives students,
faculty and staff an opportunity to decide for themselves if
ghosts really exist.

MONTEVALLO

THE UNIVERSITY OF MONTEVALLO

The University of Montevallo is located just south of Birmingham. The university is the realization of the dream of educator and social activist Julia Tutwiler, who envisioned an institution where young women could acquire skills that would enable them to become self-sufficient. As a result of the urging of Tutwiler and citizens of Montevallo, Senator Solomon Bloch introduced a bill establishing the school in the small town of Montevallo. Alabama's Girls' Industrial School opened its doors in October 1896. The Industrial School was housed in a number of existing structures. The largely experimental school trained young women to become teachers, musicians, artists, milliners, bookkeepers and telegraphers. By 1899, four hundred students were enrolled at Alabama's Girls' Industrial School. In the early 1900s, the school adopted purple and gold as its school colors. In 1907, the new president of the university, Thomas Palmer, upgraded the existing teacher training program, mostly because the demand for industrial training was declining. Under Palmer's guidance, the school became one of the first institutions in the

Palmer Hall, University of Montevallo.

state to promote teacher education in music, art, commercial subjects and physical education.

In 1911, the school changed its name to Alabama Girls' Technical Institute; the phrase "College for Women" was added to the school's name in 1919. In 1923, the school became a degree-granting institution after changing its name to Alabama State College for Women. In the 1950s, faculty, alumnae and the board of trustees gradually accepted the fact that in order for the school to grow, it would have to lose its designation as a "girls'" school. On January 15, 1957, the state legislature changed the name of the school to "Alabama State College," thereby transforming it into a coeducational institution. By the end of the decade, intercollegiate baseball, basketball, cross-country track and tennis teams were organized. In 1963, over 40 percent of the student body was men. When Alabama College became the University of Montevallo on September 1, 1963,

it included four colleges: Arts and Sciences, Fine Arts, Business and Education. In 1995, the University of Montevallo became one of twenty-five institutions to be offered membership in the prestigious Council of Public Liberal Arts Colleges. Today, the university has the distinction of being ranked by the *U.S. News & World Report* as a "Tier One master's-level" institution. Montevallo is also reputed to be one of the most haunted universities in the entire state.

The oldest building on the campus of the University of Montevallo was originally a private residence. In the early 1800s, the site on which the university is now located was occupied by a tribe of Indians and a wealthy merchant named Edmund King. Born in Virginia in 1782, he married Nancy Ragan in 1812 in Griffin, Georgia. In 1815, King, accompanied by two servants, traveled to Mobile. They then rode on horseback from Dallas County northward to a community known as Wilson's Hill. He was so impressed with the place that he and his servants built a log cabin on a picturesque site. In 1817, King moved his wife Nancy and their children to the community that would come to be known as Montevallo. Their guide was William Weatherford, the Indian warrior known as Red Eagle. In 1823, King set about building a house that reflected his increasing prosperity. He replaced the hewn-log structure where he and his family had lived for six years with a handsome brick building, built in the Federal style. Servants made the bricks of clay from Shoals Creek. Visitors traveled from miles around to gaze at the windows, which had genuine glass panes. Before long, the mansion house, reputed to be one of the finest homes in the entire state, became the social center of Montevallo and the surrounding area.

Edmund King eventually opened a successful mercantile store in Montevallo. However, King's fortune did not insulate him from tragedy. In 1842, his wife Nancy died at the age of

Front view of the King House, University of Montevallo. *Courtesy of the Library of Congress.*

Rear view of the King House. *Courtesy of the Library of Congress.*

forty-nine. His second wife, Susan Ward King, whom King married in 1848, died in 1850. Both of King's wives are buried in the little cemetery next to the King House, not far from the grave of his son Lyttleton, who was accidentally killed by one of his brothers while deer hunting. It is said that King spent hours walking around the graves, sometimes forgetting to eat. His last years were marked by infirmity and recurring illness. King died on June 28, 1863, at the age of eighty-two. Some say that he was strolling through the orchard in the back of his house when an overhanging limb fell on his head and killed him. Others believe that he died in a fall from a peach tree that he was trying to climb.

However, according to local legends, the death of Edmund King was not the end of his story. For years, people reported seeing his ghost wandering around with a lantern and a shovel, reportedly looking for the gold that he had buried under a peach tree. Sometimes, his spirit takes the form of a ball of light that has been seen darting around the area between the graveyard and the orchard. Dr. Frank McCoy, a retired professor in Montevallo's Fine Arts Department, told of his own encounter with the spectral figure:

It was my first year here—1976. I was hired by President Kermit Johnson, who had already retired from being a principal and superintendent in Birmingham. He seemed to be really old to me back then. Students talked about seeing the house's ghost, and we decided to stake out the place. My office was in Brock Hall right across the street. We decided to wait after nightfall to see if we could catch sight of him. Sure enough, we looked up one night, and we saw this shadowy figure walking around the outside of the house, bending over [like he was looking for something buried in the

ground]. *Everywhere this figure went, it suddenly got very dark. One part of the yard went dark, and then another and then another. I figured out that it was the president, Kermit Johnson, who was going around turning off the outside lights to keep the utility costs down. The lights were on the ground, and he had to bend over.*

The children and grandchildren of Edmund King also spoke of strange activity inside the King House. For years, King's relatives have experienced cold spots in King's bedroom. People sitting in the downstairs parlor reported hearing the creaking of the bed and footsteps, as if someone had just climbed out of bed and walked across the floor. They immediately thought of Edmund King, who was in the habit of leaving his bed and pacing the floor of his bedroom in his old age. As soon as someone opened the door, the noises stopped. King's descendants also claimed to have seen weird lights in the dark corners of the upstairs room, usually on stormy nights. They also heard the clinking sounds of coins. Dr. Frank McCoy said that students and faculty reported seeing his ghost counting his money in one of the upstairs windows. "At times, he will lose money, or he can't figure out why his books won't balance," McCoy said, "and he starts roaming the inside of the house."

In 2008, a group of paranormal investigators, Birmingham Paranormal, gathered some very strong evidence at the King House, including the movement of "shadow people" on the stairs and bedrooms, strange odors and the EVP of a human voice.

The most bizarre occurrence inside the King House was reported by Kathryn Tucker Windham in her book *Jeffrey's Latest 13: More Alabama Ghosts*. Windham reports that years after King's death, a wedding feast was held inside the mansion. A young girl, possibly a bridesmaid, was trying to carve a roast pig when

a high-pitched squeal came from the animal. Panic-stricken, guests overturned chairs and bumped into the banquet table as they dashed out the front door. While they were regaining their composure on the front lawn, one of the groomsmen volunteered to carve the pig. He had just stuck a large fork into the pig when what guests later described as a "huge white thing" floated from underneath the table, hovered over the bride and groom and disappeared. Needless to say, no one felt like eating after the spirit vanished. Later on in the evening, while the bride and groom and their guests were dancing, a white-robed figure leapt through the parlor door, floated over the heads of the guests and flew out an open window into the night. To this day, no one knows who—or what—the uninvited wedding guest was.

Even today, students talk of the ghosts inside the King House. One night, several members of the baseball team claim to have broken into the old house when they heard a spectral voice order them to "Get out!" Students passing by the house during the day have seen the transparent figure of an elderly man dressed in nineteenth-century clothing waving at them from a second-story window. At night, students have seen the light of a lantern move from room to room on the second floor. People standing inside the kitchen of the King House have reported getting "bad vibes." One evening, a young man and woman were walking around the outside of the King House, staring into the windows. The young man was looking into one of the kitchen windows when, suddenly, he felt a hand on his shoulder. Thinking that his friend was trying to get his attention, he turned around to find out what she wanted. To his surprise, she was standing across the brick patio, staring into an upstairs window.

One of the buildings that became the nucleus of Alabama Girls' Industrial is now known as Reynolds Hall. During the Civil War, the building was used as a Confederate hospital. Dr. Frank

Montevallo

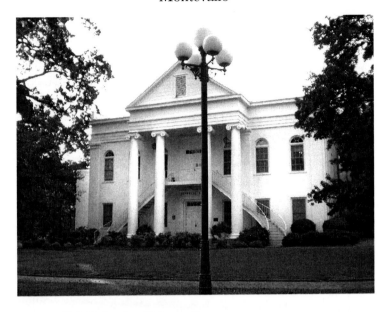

Reynolds Hall, University of Montevallo.

McCoy believes that Reynolds Hall is haunted by the ghost of Captain Henry Clay Reynolds, whose duty it was to protect the sick and injured men in the hospital:

> *Captain Reynolds learned that General Sherman's troops were about to attack the Briarfield Iron Works, which was a very valuable smelting facility for the Confederates, so he decided to go eight miles from Briarfield and join the troops. Unfortunately, he left the wounded soldiers in Reynolds unguarded, and when the Union army came through, they massacred the wounded. Reynolds came back from Briarfield and was anguished over the fact that he had not died on the battlefield. He regretted not staying in Montevallo to protect the wounded men. Captain Reynolds said he'd never go from Reynolds Hall again, so he never left.*

Legend has it that the bodies of the murdered patients were buried in the King cemetery. Some people believe that Reynolds's spirit is guilt ridden over his actions during his tenure as the first president of the school. Reynolds had been one of the primary supporters of Montevallo as the site of the proposed Girls' Industrial School. Supposedly, Reynolds's ghost is racked with guilt because he was forcibly removed as president. His detractors claimed that he had invested the students' tuition money to fatten his own bank account.

For generations, students, faculty and staff have had paranormal experiences in Reynolds Hall. Some of the disturbances in the building seem to be poltergeist activity. Janitors claim that doors and windows open and close by themselves. People walking through the building at night have passed through what seem to be cold spots. Occasionally, people have felt a gust of wind blowing across the stage when the doors are closed. Most people credit these phenomena to Henry Clay Reynolds, whose blue apparition has been seen and heard walking around Reynolds Hall. Some students actually claim that Reynolds's specter has followed them around the campus late at night. The best-known ghostly activity in Reynolds Hall involves the portrait of the disgraced president. Dr. Frank McCoy said, "I have been over to Reynolds Hall on nights when maintenance people will swear that Reynolds's portrait has been moved. They will take it down and move it back to its proper place. No one has ever been caught moving it, but it does in fact move around the building."

The ghostly presence at Palmer Hall is the spirit of Dr. Walter H. Trumbauer, known affectionately by the student body as "Trummy." Dr. Trumbauer founded the Drama Festival in 1928. He was also the driving force behind College Night, which began on March 3, 1923. Dr. McCoy explained,

Montevallo

King House cemetery.

College Night has been recognized by the Smithsonian Institution as having the longest-running continuous student-produced and -directed show in the country. It is a really intense rivalry. You declare that you are gold or purple, the school colors. Then you go through various athletic competitions, followed by debates. Then it culminates in a series of nights, beginning on Wednesday and ending on Saturday. Each group writes, produces, choreographs and acts in a production it has written. Then on Saturday, a winner is declared. Probably no more than ten days a year do students have an interest in Palmer Hall, but during that time, the rivalry and intense emotions are raucous on College Night.

Dr. Trumbauer had a vested interest in Palmer Hall and its 1,100-foot auditorium because he helped design it. Apparently,

though, Dr. Trumbauer's spirit is still miffed because his name was omitted from the plaque on the outside of the building. Dr. McCoy says that Trummy's restless spirit is most active during the performance of plays: "Trummy will wander backstage and appear and disappear as students are getting ready, causing the performers to become even more jittery than they were before walking on stage." Students can tell which play meets with Trummy's approval because he causes the battens to swing over the performance of his choice during dress rehearsal. Students say that Dr. McCoy suspects, however, that there might be a rational explanation for the manifestations inside Palmer Hall. "Most of these students have never appeared on stage before and certainly not in front of a thousand people with bands playing and cheerleaders and that sort of thing. So the fact that they would see an apparition in the labyrinth below the stage is understandable."

Another haunted building on Montevallo's campus is Hanson Hall Women's Residence. The story goes that the spirit of a strict housemother is still watching over the young women in the dormitory. She usually takes the form of an unseen presence that looks over the shoulders of students as they study late into the night. Her ghost has also been seen walking down the halls and peering into students' rooms to make sure that everything is as it should be. The vigilant housemother has also been credited with moving objects from their original locations. One student said that she left her coffee mug on her desk, only to find it gone a few minutes later. The mug reappeared in the same location a few weeks later.

The University of Montevallo's most famous ghost story takes place in at the oldest residence hall, Old Main. The four-story west wing of Old Main opened its doors in 1897. Students have given the old dormitory the nickname "Buzzard Hall," probably because the tangle of vines encircling the entranceway is said

to resemble buzzards' nests. Old Main's most famous resident is Condie Cunningham, who lived on the fourth floor. On February 4, 1908, she and her friends were heating up hot chocolate on a burner when someone knocked over a bottle of alcohol, which splashed on Condie's nightgown and ignited it and her hair. Screaming, the terrified girl ran out of her room and down the hallway. Finally, she collapsed in a smoldering heap at the foot of the stairs. Condie was taken to a local hospital, where she died several days later. Students said that they could still smell the stench of burned flesh on the fourth floor several days later. According to Dr. Frank McCoy, stories of Condie's ghost began circulating around Old Main shortly after her death:

> *Even today, you can talk to students who swear that Condie came into their room. She's been known to go into the shower areas and scream her head off. Some students have felt a breeze when the windows were closed. They have seen the carpet on the threshold of her room ripple as if someone walked into the room. Or they tell the story of a door opening, and there won't be anyone there. The girls say that when she roams the hall, she doesn't do it quietly. She runs and screams through the hall as if she is still on fire. One student told me that Condie is coming back because she is trying to live vicariously through the young students in the hall.*

Students have also heard a voice crying "Help me!" and disembodied footsteps running down the hall. One young woman claimed to have seen the apparition of a woman in a nineteenth-century dress standing by her bed, criticizing her for having a boy in her room after hours. The ghost of Condie Cunningham is so famous that Old Main has been featured on television programs and radio shows like *Rick and Bubba*.

Condie Cunningham's face is reputed to appear on the door to her old room.

In 2002, I, accompanied by Dr. Frank McCoy and a resident advisor, visited Old Main. At the time of my visit, her room was unoccupied. Supposedly, no one could stay there very long because of the spectral sounds in the room. Dr. McCoy said that the door to her room was not the original door: "Students began to see the image of a woman screaming in the wood grain panel of the door to her room. Her hair was on fire, and the flames were shooting up. There were maintenance people who claim that they saw the image too. It wasn't just the students who saw her. A few years ago, somebody decided to put the door in storage to put the school at ease." The RA took Dr. McCoy and

Condie Cunningham's bedroom is not always as empty as it appears.

me to the basement, where the door is stored. I can understand how someone with a healthy imagination who is familiar with Condie Cunningham's tragic tale could make out the image of a screaming woman in the intricate pattern of streaks and swirls on the wood. A variation of the story has it that the image on the door is the face of a young woman who hanged herself in Condie's room. She has also been credited with opening and closing the doors to rooms on the fourth floor, including the doors to the bathroom stalls.

Ghost stories are still told in the dormitories at the University of Montevallo, but not as much as they were in the past. Dr. Frank McCoy attributes this erosion of the transference of campus lore to the changing face of the university:

> *Back in the '70s and '80s, there were much closer connections between students and faculty because they didn't know that we didn't know everything, so what developed was the faculty*

perpetuated many of the ghost stories on the campus. They would have the students at their homes. What are you going to talk to an eighteen-year-old about over dinner? You are not going to talk about math or science or art history. You're going to talk about campus life, and there are few things more interesting than ghosts, so it became almost traditional that faculty would tell ghost stories. This is not done so much because there are fewer students living on campus. Only about one third of the student body lives on campus now, so many of these student/faculty relationships have not continued.

One can only hope that the current interest in the paranormal, spawned in large part by television, will inspire students to investigate the truth behind the stories that have made the University of Montevallo very well known to ghost hunters across the United States.

BIBLIOGRAPHY

BOOKS

Brown, Alan. *The Face in the Window and Other Alabama Ghostlore.* Tuscaloosa: University of Alabama Press, 1996.

————. *Haunted Places in the American South.* Jackson: University Press of Mississippi, 2002.

————. *Stories from the Haunted South.* Jackson: University Press of Mississippi, 2004.

Lewis, W. David. *Sloss Furnaces and the Rise of the Birmingham District.* Tuscaloosa: University of Alabama Press, 1994.

Miller, Elaine Hobson. *Myths, Mysteries, & Legends.* Birmingham, AL: Seacoast Publishing, 1995.

Stars and Bars: Walker College Yearbook. 1993.

Whitmire, Cecil, and Jeannie Hanks. *The Alabama Theater: Showplace of the South.* Birmingham, AL: Birmingham Landmarks, Inc., 2002.

Windham, Kathryn Tucker. *The Ghost in the Sloss Furnaces.* Birmingham, AL: Birmingham Historical Society and First National Bank of Birmingham, 1978.

————. *Jeffrey's Latest 13: More Alabama Ghosts.* Tuscaloosa: University of Alabama Press, 1982.

WEBSITES

ABC 33/40 News. "Tracking Down Birmingham Area Ghosts." www.abc3340.com/news/stories/1008/565920.html.

Angelfire. "Birmingham." www.angelfire.com/al2/RMB2000/mp1.html.

Bessemer Hall of History Museum. "Bessemer's Historic Railroad Passenger Terminal." www.bessemerhallofhistory.com/history.htm.

Bevill State Community College. "History of Bevill State Community College." www.bscc.edu/about_history.php.

Bhamwiki. "Alabama Theatre." www.bhamwiki.com/w/Alabama_Theatre.

————. "Redmont Hotel." www.bhamwiki.com/w/Redmont_Hotel.

Birmingham Public Library. "History of Birmingham Public Library." www.bplonline.org/about/history.

Blog.uncovering.org. "The Many Faces of Jesus." blog.uncovering.org/en/archives/2008/08/the_many_faces_of_jesus.html.

BookRags. "Sloss Furnaces." www.bookrags.com/wiki/Sloss_furnaces.

Ghost Chasers International, Inc. "The Sloss Furnaces." www.ghosthunter.com/airline.htm.

Ghostinvestigator.tripod.com. "Haunted Montevallo Campus." ghostinvestigator.tripod.com/alabama.g.i.s/id31html.

Ghost Stories. "Sloss Furnace." paranormalstories.blogspot.com/2005/10/sloss-furnace.html.

Hank Williams: The Complete Website. "The Death of Hank Williams." www.angelfire.com/country/hanksr/death.htm.

HauntedHouses.com. "University of Montevallo." www.hauntedhouses.com/states/al/university_of_montevallo.cfm.

Historic Hotels & Lodges. "Virtual Tour of the Redmont Hotel—Ghosts." www.historic-hotels-lodges.com/alabama/redmont-hotel/redmont-hall.html.

Interment.net. "Bass Cemetery: Irondale, Jefferson County, Alabama." www.interment.net/data/us/al/jefferson/bass/index.htm.

Lichtenstein, Alex. "Industrial Archeology." NPS Archeology Program. www.nps.gov/history/archeology/Cg/fd_vol7_num2/engine.htm.

Madame Talbot's Victorian Lowbrow. "Hazel Farris Mummy Sideshow Broad Sheet Poster." www.madametalbot.com/pix/vintage/vin20.htm.

Oxford Paranormal Society. "Sloss Furnaces." www.oxfordparanormalsociety.com/slossfurnaces.html.

Paranormalknowledge.com. "The Ghosts of the University of Montevallo." www.paranormalknowledge.com/articles/the-ghost-of-the-university-montevallo.

Rootsweb. "Shelby County Historical Society, Inc.: Museum & Archives." www.rootsweb.ancestry.com/~alshelby/schs.html.

SlossFrightFurnace.com. "Haunted History of Sloss Fright Furnace." www.frightfurnace.com/hauntings/history5.asp.

Sloss Furnaces National Historic Landmark. "The Sloss Story." www.slossfurnaces.com/media/html/sloss_story/index.html.

Strangeusa.com. "Old Courthouse." www.strangeusa.com/ViewLocation.aspx?locationid=1233.

Theredmont.com. "The Redmont Hotel & Residences: Live the Legacy, Experience the Redmont." www.theredmont.com/abouttheredmont.shtml.

University of Montevallo. "Brief History of the University of Montevallo." www.montevallo.edu/montevallo/BriefHistory.shtm.

Watchlocalvideos.com. "Bass Cemetery Ghost Hunting." www.watchlocalvideos.com/watch-2142.htm.

Wikipedia. "Birmingham, Alabama." en.wikipedia.org/wiki/Birmingham,_Al.

———. "Hazel Farris." en.wikipedia.org/wiki/Hazel_Farris.

———. "Perceptions of religious imagery in natural phenomena." en.wikipedia.org/wiki/Perceptions_of_religious_imagery_in_natural_phenomena.

———. "Sloss Furnaces." en.wikipedia.org/wiki/Sloss_Furnaces.

———. "WIXI." en.wikipedia.org/wiki/WIXI.

Williams, Yona. "Haunted Alabama Spots. Unexplainable.net. www.unexplainable.net/artman/publish/article_2911.shtml.

INTERVIEWS

Baggett, Jim. Personal interview. May 26, 2000.

Bates, Ron. Personal interview. March 10, 2000.

Cooksey, Hazel H. Personal interview. July 29, 1993.

Fout, Deborah. Personal interview. December 19, 2001.

Giordano, Bob. Personal interview. October 26, 2008.

Harwell, Edith. Personal interview. March 17, 2002.

McCoy, Dr. Frank McCoy. Personal interview. April 12, 2000.

Moode, Steve. Personal interview. July 12, 2002.